Network for Change

St Ives Artists: A Companion

Virginia Button

Tate Publishing

First published 2009 by order of the Tate Trustees
by Tate Publishing, a division of Tate Enterprises Ltd,
Millbank, London SW1P 4RG
www.tate.org.uk/publishing

British Library Cataloguing in Publication Data
A catalogue record for this book is available from
the British Library

ISBN 978 1 85437 820 0

Distributed in the United States and Canada by
Harry N. Abrams, Inc., New York

Library of Congress Cataloging in Publication Data
Library of Congress Control Number: 978 1 85437 820 0

Designed by Fraser Muggeridge studio
Printed in Spain by Grafos

Cover: Bryan Pearce, *Westcott's Quay* 1980 (detail of **fig. 68**)

Measurements of artworks are given in centimetres,
height before width

'St Ives' Artists: An Introduction

In 1942, at Barnoon Cemetery in St Ives, writer and painter Adrian Stokes interrupted a pauper's burial. Stokes remembered that although the old man had ended his days in Madron workhouse, he had put money aside for a proper funeral.[1] A few days later his wishes were honoured, and tiles by the celebrated St Ives potter Bernard Leach were made shortly after to adorn his grave (fig.1).

The deceased was retired seaman and marine rag-and-bone merchant Alfred Wallis, who had taken up painting after the death of his wife to combat loneliness. The immediacy of his 'naive' images, which conjured up a lost, more innocent world, together with his noble poverty, made him a talisman for many artists identified with what became known as the 'St Ives School'. This community of artists, gathered around a remote Cornish fishing town facing the Atlantic, made a significant contribution to international modernism in the decades immediately following the Second World War. The figure of Wallis alone cannot account for their extraordinary achievement. But his iconic status as Britain's authentic 'primitive' painter provides a useful starting point for this introduction: Wallis's instinctive response to the world struck a chord with a generation of artists who looked to nature, and to themselves, during the devastation and uncertainty of war and its aftermath (fig.2).

Though labelled the 'St Ives School', the artists featured in this book are perhaps better described as a network of painters and sculptors who either lived in or were associated with the town through friendships, connections and shared preoccupations. Committed to modern ideas, most of them pursued the possibilities of a nature-based abstraction. Seminal accounts of the 'St Ives School' such as Denys Val Baker's *Britain's Art Colony by the Sea* of 1959 have emphasised the seduction of its artists by the romantic power of west Cornwall's dramatic, ancient landscape and surrounding sea. A comment by John Wells has often been quoted to sum up 'St Ives' art, which typically draws on nature and the artist's emotions in equal measure: 'If I paint what I see the result is deplorable. But how can one paint the warmth

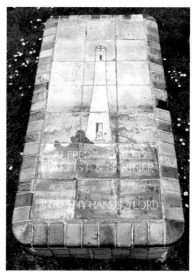

Fig.1 Grave cover of painted stoneware tiles by Bernard Leach for Alfred Wallis in Barnoon Cemetery, St Ives 1942

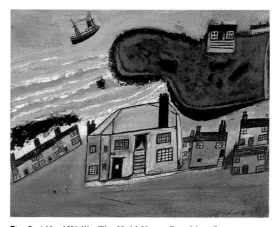

Fig.2 Alfred Wallis, *The Hold House Port Mear Square Island Port Mear Beach*, c.1932
Oil on board, 30.5 × 38.7 Tate

of the sun, the sound of the sea or the journey of a beetle across a rock or thoughts of one's own whence and whither?'[2] While this commitment to nature as a primary source for art might well be explained in terms of a romantic tradition, it should also be considered in the context of ideas about modern art at that time.

The desire for authenticity shared by many 'St Ives' artists – often conveyed through a raw, visceral physicality and a sense of higher consciousness or spirituality – appealed to post-war sensibilities. In a period of shattered ideals, nature provided an infallible touchstone for 'real' experience. As a reworking of abstraction, which had expressed the utopian dreams and aspirations of the inter-war avant-garde, 'St Ives' art had the appearance of a modern idiom. But its exploration of individual, subjective experience made it more personal, more human. In a world dehumanised by war, it might be viewed as an art of solace and hope.

For the most part, artists gravitated to west Cornwall during and after the war because its geographical location offered a safe haven. In different ways, they might be regarded as refugees, for whom art became a means of questioning the nature of existence and for building a better life. Like other regional fringes, west Cornwall also came to signify a particular set of values of the kind embodied by the figure of D.H. Lawrence, who had in fact lived on the moors of Zennor during the First World War. Lawrence notoriously lived out his interest in the idea of 'primitivism', flouting bourgeois norms. For him, Cornwall offered both a place for simple living and an escape from social approbation. In the same spirit many of the 'St Ives' artists viewed their relative poverty and isolation as a form of resistance to the growing tide of post-war consumerism and mass communications.[3] In this sense, 'St Ives' came to represent an alternative model of community during a period of unsettling, rapid social transformation. It is perhaps no co-incidence that a number of the 'St Ives' artists had childhood memories of Cornwall, nostalgic memories of a more innocent time.

Most of the artists included in this book were involved in some way with the Penwith Society of Arts in Cornwall. Founded in 1949 as a non-partisan, local art group, the Penwith attracted funding from the newly established Arts Council, which was charged with the responsibility of regenerating culture in the regions. The positioning of a 'St Ives School' on the international stage was made possible by such changes in the state support of art, and by the post-war development of the international art scene. The idea of 'St Ives' was intrinsically underpinned by its peripheral, rural location. Yet, through the Penwith, and such important 'connectors' as Barbara Hepworth, Ben Nicholson, Peter Lanyon and Patrick Heron, its art community operated firmly within the dominant metropolitan national and international art centres.

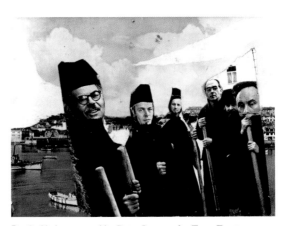

Fig. 3 Christmas card by Peter Lanyon for Terry Frost. Left to right: Terry Frost, Bryan Wynter, Peter Lanyon, Roger Hilton and Patrick Heron, St Ives Harbour in background
Tate Gallery Archive

1880s to 1920:
St Ives Becomes an Art Colony

Numerous artists have been – and continue to be – drawn to the Penwith peninsula, contributing in different ways to the reputation of the region as a creative centre. From the mid-nineteenth century, artists in France began establishing colonies in remote, rural places seeking new subject matter and cheap studio space. This model of practice was soon adopted by artists across Northern Europe. By the 1880s, British artists had similarly set up colonies in the harbour towns of Newlyn and St Ives, charmed by picturesque views, the quality of the light and the idea of a simple way of life. The Newlyn School developed under such artists as Walter Langley, Stanhope Forbes and T.C. Gotch, who practised a type of social realism exemplified by the French painter Jules Bastien-Lepage. A number of Newlyn painters gained popularity and critical recognition, which enhanced the colony's status. For example, Frank Bramley's

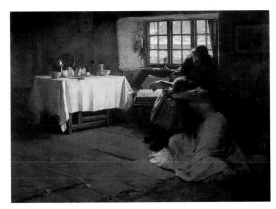

Fig. 4 Frank Bramley, *A Hopeless Dawn* 1888
Oil on canvas, 122.6 × 167.6 Tate

Fig. 5 Artists' Show Day, St Ives, March 1935 Tate Gallery Archive

A Hopeless Dawn of 1888, a crowd-pleasing melodrama depicting the plight of fishermen and their families, was acquired for the nation by the Chantrey Bequest (**fig. 4**).

St Ives in particular was favoured by cosmopolitan artists, no doubt encouraged by the arrival of the Great Western Railway in 1877 and provision of attractive accommodation, in the form of facilities like the Tregenna Castle Hotel, which opened shortly after. In 1887 James Lanham provided a gallery space for local artists in his general merchants' and artists' materials shop, and the St Ives Arts Club was formed the following year. In 1896, Julius Olsson, who became well-known for his stormy sea paintings, helped found an 'atelier' style art school for marine painters in Porthmeor Studios, which had been converted from fish lofts along the eastern end of Porthmeor Beach in the late 1880s. With the availability of studio space and tuition, St Ives became increasingly popular with aspiring young artists, often from abroad.

Although considered by contemporaries as 'Bohemian', the social milieu of the colony was educated, middle-class and respectable. Many artists in St Ives (and Newlyn) were well-connected to professional artists teaching in London's art institutions. Every spring artists sent their work to annual exhibitions in London and the continent. Before pictures were packed off, one day in March – known as 'show day'– studios were opened to the public, a hugely popular practice that continued into the early 1950s (**fig. 5**). During the first decades of the twentieth century, as the local industries of fishing and tin-mining faced terminal decline, art tourism became increasingly important to the regional economy. Artists visiting St Ives between the mid-1880s and the 1920s included, for example, James McNeill Whistler, Walter Sickert, Frances Hodgkins, Matthew Smith (**fig. 6**) and Cedric Morris.

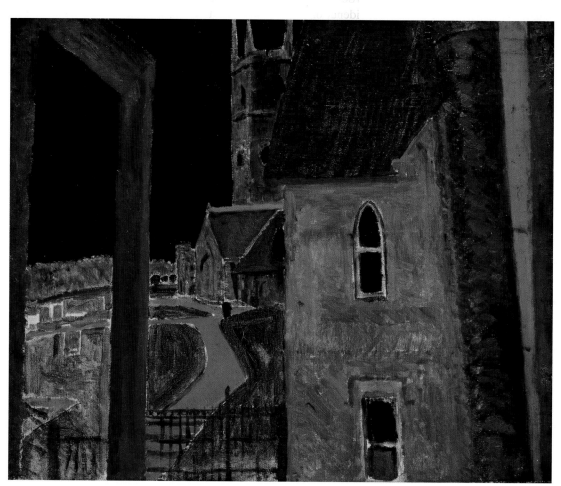

Fig. 6 Matthew Smith, *Cornish Church* 1920
Oil on canvas, 53.3 × 64.8 Tate

1920s to 1930s:
St Ives and English Modernism

During the inter-war years the established colony continued to thrive. In 1927 the St Ives Society of Artists was established under the Presidency of Moffat Lindner, who bought Porthmeor Studios as an exhibition gallery for its members. But the arrival of Bernard Leach and his pottery in 1920 was to make the town internationally famous. Though trained as a painter and printmaker, Leach became fascinated with Japanese ceramics while living in Japan between 1909 and 1920. On his return to Britain he was invited with his friend and associate Shoji Hamada to set up a pottery in St Ives by a wealthy patron keen to stimulate local employment. Despite the area's lack of suitable clays and timber for kiln-firing, Leach nevertheless managed – initially with Hamada's help – to develop a highly successful practice based on the vision of the artist-craftsman.

Inspired by the ideas of William Morris's nineteenth-century Arts and Crafts movement, Leach set out to revive the handmade simplicity of pre-industrial traditions. Drawing on Eastern and Western philosophies, he combined the lost traditions and 'spirit' of English country slipware with oriental ideas of craftsmanship to produce practical, beautiful objects, suited to modern needs. Over the years Leach took on many assistants and visiting students. The pottery became an important factor in creating links between the wider local community and artists in St Ives (fig. 7).

Leach's activities can be seen in the context of a wider craft revival between the wars, which also influenced the direct carving techniques of such modern British sculptors as Henry Moore and Barbara Hepworth, and the visibly handmade quality of paintings by Christopher Wood and Ben Nicholson. The latter three artists also became key figures in the development of 'St Ives'.

In autumn 1928 St Ives provided the backdrop for Ben Nicholson and Christopher Wood's chance 'discovery' of Alfred Wallis, regarded as a pivotal moment in the development of modern painting in England. Later to play a major role in the 'St Ives School', Nicholson was already a force in English modern art. He was decidedly international in outlook and open to many influences, exploring Cubism and making a few early attempts at abstraction. During the later 1920s, he and his wife, the painter Winifred Nicholson, formed a friendship with the young and talented Paris-based painter Christopher 'Kit' Wood. Painting together, they aimed to develop a 'primitive' authenticity using a naive style and subject matter. The Nicholsons' Christian Science beliefs and the values of the Arts and Crafts movement influenced their dedication to simplicity in art and life. Their interest in the pre-industrial ethos of Arts and Crafts and in pre-Renaissance 'primitive' Italian painting – shared with other modern English artists at the time – reflected a desire to go 'back to basics' following of the devastating catastrophe of the First World War and its chaotic aftermath.

Wallis used household paint on whatever support he could find, including odd-shaped wooden boards and card with pinholes. To Ben and Kit, his rough and ready images appeared to be the work of a true 'primitive', and they quickly appropriated his boat and lighthouse motifs (figs. 8, 9). For Nicholson in particular, a more enduring influence was the old mariner's use of unconventional materials, and his combined use of memory and experience to realise an image. Paying tribute after his death Nicholson wrote: 'About Alfred Wallis: the essential part of his idea as that he worked like the first man will have worked, using the materials to hand (a cave or a cardboard) in order to make an experience. To Wallis his paintings were never "paintings" but actual events'.[4]

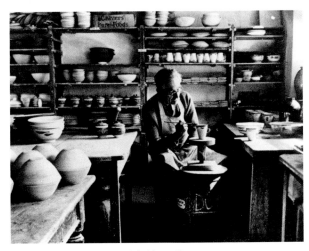

Fig. 7 Bernard Leach at work in his studio Tate Gallery Archive

Fig. 8 Ben Nicholson, *1928 (porthmeor beach)*
Oil and pencil on canvas, 90 × 120 Private Collection

Fig. 9 Christopher Wood, *Porthmeor Beach* 1928
Oil on canvas, 46.5 × 55.2 Private Collection

In the early 1930s Nicholson moved from Cumbria to Hampstead in London to be with his new partner, the sculptor Barbara Hepworth. Carving in stone or wood, Hepworth – together with her friend Henry Moore – was experimenting with the modernist idea of 'truth to materials', allowing simplified forms to emerge naturally from their chosen medium. Nicholson and Hepworth forged links with artists of the French avant-garde, such as Picasso, Braque, Brancusi, Mondrian and Jean Hélion. With a growing community of like-minded friends and émigrés from continental Europe they championed international abstract or 'constructive' art. During a period of increasing threat from dictatorships in Germany and Russia, they believed in abstraction's unifying power. Nicholson gained notoriety in the 1930s with a series of radically pared-down geometric abstractions known as the 'white reliefs' (**fig. 10**). Part painting, part sculpture they combined the improving aims of modern design with the expression of a universal, spiritual truth. Yet, in 1930s England his rigorous abstraction was dismissed as cold, intellectual and too programmatic to represent democratic freedoms.

Undeterred, in 1937 Nicholson and his friends the Russian artist Naum Gabo and architect Leslie Martin launched *Circle: An International Survey of Constructive Art*, announcing 'a new cultural unity'. But only a few years later, dreams of a unified culture were shattered by the outbreak of war. Fearful of bombardment in London, Nicholson and Hepworth took their young family to live in Carbis Bay, near St Ives, staying initially with their Hampstead friends Adrian Stokes and his artist wife, Margaret Mellis, who had moved there in 1938. They were followed shortly by Gabo and his wife Miriam. As the international art world fragmented, three of its leading and most sophisticated practitioners in England found themselves together in Cornwall.

Fig.10 Ben Nicholson, *1935 (white relief)*
Oil on carved panel, 101.6 × 166.4 Tate

1939–1945:
The War Years

The conditions of war brought the diverse groups of artists working in an around St Ives closer together. The established art community, whose key members included Lindner, Borlase Smart, John Park, Leonard Fuller and his wife Marjorie Mostyn, the Leach Pottery, and younger artists, notably St Ives-born Peter Lanyon, gradually became aware of the Hampstead refugees. A prominent member of the St Ives Society of Artists, Smart was particularly instrumental in welcoming the newcomers.

In the early 1940s wartime privations made it extremely difficult for artists to continue making work. Nicholson was under financial pressure to make saleable landscape pictures, but he continued to experiment with advanced styles – if only on a small scale – and to promote abstract art. Through articles and exhibitions he publicised the work of younger artists gathering in St Ives who were sympathetic to abstract and modern idioms, including Sven Berlin, Lanyon, Mellis and her friend Wilhelmina Barns-Graham, who arrived from Scotland in 1940. There was also John Wells, who worked as a doctor on the Scilly Isles during the war, whom Nicholson had first met in Cornwall in 1928.

The move to Cornwall encouraged Nicholson, Hepworth and Gabo to intensify the references to nature already existing in their work. Nicholson began to depict motifs from St Ives and its environs, while his abstract paintings and reliefs reveal a greater sense of natural colour and texture fig. 11). Hepworth, who was unable to produce sculpture for much of the war, became interested in Stokes's speculations on the relationship between the human body and the surrounding space of the landscape. For example, her *Landscape Sculpture* of 1944 (originally made in wood but cast in bronze in 1961) evokes a physical experience of landscape. Its hollowed centre is only fully understood when moving around the work, while two stringed planes serve to suggest both space within the form, and such bodily components as sinews or nerves (fig. 12).

Gabo was mostly restricted to drawing and carving small pieces of stone until 1940 when he secured supplies of the hi-tech, clear plastic that had become his trademark material. Based on an idea from the 1930s, *Spiral Theme* of 1941 shows him responding to his new environment (fig. 13). The translucent, apparent weightlessness of its moulded, Perspex form suggests such natural phenomena as light moving across water, while a dynamic twisting spiral animates its core. Gabo left St Ives for America in 1946. As pioneering international modernists, Nicholson and Hepworth inspired the younger generation, but Gabo's constructivist pursuit of pure form and passionate interest in the hidden forces of nature made a deep impact on what was to become celebrated as 'St Ives' art.

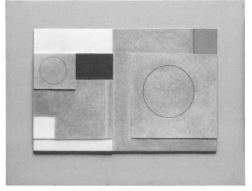

Fig. 11 Ben Nicholson, *1939–44 (painted relief)* Oil on board, 16.5 × 25.4 × 6 Tate

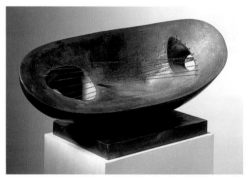

Fig. 12 Barbara Hepworth, *Landscape Sculpture* 1944 Bronze (cast 1961), 31.5 × 62 × 28.5 Tate

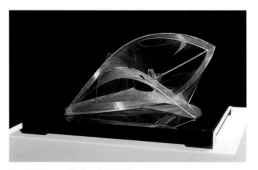

Fig. 13 Naum Gabo, *Spiral Theme* 1941 Cellulose acetate and perspex, 14 × 24.4 × 24.4 Tate

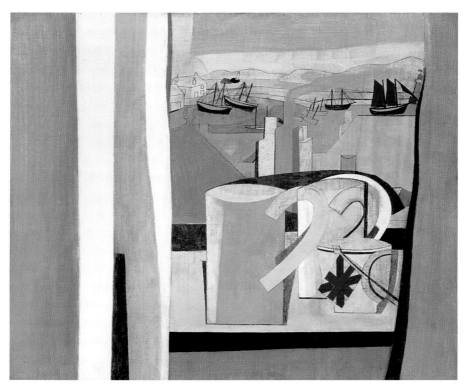

Fig. 14 Ben Nicholson, *1943–45 (St Ives, Cornwall)*
Oil and pencil on canvas board, 40.6 × 50.2 Tate

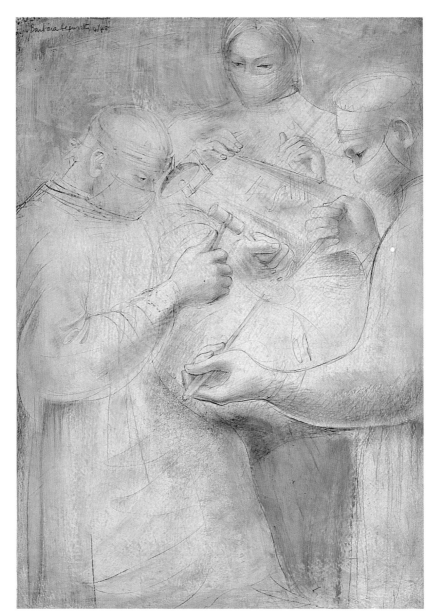

Fig. 15 Barbara Hepworth, *Fenestration of the Ear*
(The Hammer) 1948
Oil and pencil on board, 38.4 × 27 Tate

1945–1960s:
The 'St Ives School'

After the war a greater number of talented, younger artists arrived in St Ives, many of them escaping grey, bomb-wrecked cities. Although tensions and factions existed between groups of artists working in the town, it gained a reputation as a mutually supportive arts community, becoming a model of regional cultural regeneration. This was largely brought about through the Penwith Society of Arts in Cornwall and the patronage it secured from the wider art world.

The 'Penwith':
Patronage and Regional Identity

In 1946 Lanyon, Wells and Berlin set up the Crypt Group, so-called as it exhibited in the crypt beneath the new St Ives Society of Artists Gallery in the old Mariner's Church. The group included Bryan Wynter, who had moved near Zennor, and the printer Guido Morris (in 1947 and 1948 two further exhibitions also featured work by Wilhelmina Barns-Graham, Kit Barker, David Haughton, Adrian Ryan and Patrick Heron). Although their work was stylistically diverse, Lanyon hoped that this younger, dynamic group would challenge the authority of the St Ives Society of Artists (fig. 16). This aim was achieved in January 1949 when he colluded with Nicholson and Hepworth to set up the Penwith Society of Arts in Cornwall, a splinter group of the St Ives Society of Artists, comprising all the modernists. They subsequently engineered the introduction of the 'ABC' rule, a system of classifying the forty members of the Penwith into the categories of representational (A), abstract (B) and craftsmen (C), which proved highly contentious and led to resignations.

By 1950 even Lanyon had resigned in protest at what he considered unfair treatment of members, and attempts by Nicholson and Hepworth to dominate the Penwith. Significantly, they had invited their close friend the respected art critic and influential arts bureaucrat Herbert Read to be the first President. This split began a feud between Lanyon and the two senior artists that helped determine his identity as a regionalist. His down-to-earth, individualistic approach to landscape was honed in opposition to what he

Fig. 16 The Crypt Group 1947 Tate Gallery Archive

Fig. 17 Ben Nicholson in his Porthmeor studio, January 1951
Tate Gallery Archive

Fig. 18 Peter Lanyon, *Headland* 1948
Oil on canvas, 51.5 × 77 Tate

perceived as their refined, international style. Lanyon subsequently joined the Newlyn Society of Artists and made it a rival power-base to the Penwith, which he dismissed as an instrument for centralising, anti-regional forces.

Despite such differences and conflicts, Nicholson and Hepworth encouraged younger artists to achieve a new level of professionalism and internationalism in their work, introducing them to key art world contacts and offering direct support. Significantly, both artists had their first exhibitions in New York in 1949. In the same year, following Nicholson's move to a bigger space at Porthmeor Studios and Hepworth's purchase of Trewyn Studio, their work grew in scale and ambition.[5] Hepworth was able to employ younger artists, for example Terry Frost, John Wells, Denis Mitchell and John Milne, as assistants. In the 1950s, Nicholson's internationally acclaimed development of a style of modern painting that held abstraction and naturalism in balance was undoubtedly important for the work of so-called middle generation St Ives artists, such as Lanyon, Heron, Frost and Roger Hilton.

Although Lanyon resented the dominance of the Penwith, Hepworth in fact shared his commitment to the notion of a local community, which he explored in his paintings of the late 1940s and early 1950s. Wartime experiences shaped Hepworth's belief in small-scale community life as an ideal social model in which artists had a defined role. She addressed this theme metaphorically in her remarkable series of hospital drawings of 1947–8. For example, in *Fenestration to the Ear (The Hammer)* of 1948 an operation is pictured as a collaborative event, with nurses and physician working harmoniously, while the physician's instrument perhaps alludes to the sculptor's tools (**fig. 15**).

Lanyon's large-scale painting *Porthleven*, commissioned by the Arts Council for the Festival of Britain in 1951, represented a significant turning point in the development of his work. The semi-abstract image depicts his bodily experience of being in the fishing village of Porthleven 'from different aspects' (**figs. 19, 20**). For Lanyon, this sensory experience, expressed through gestural paint and fragmented perspective, ambitiously combined themes of history, geology and myth, while a human presence is suggested by the form

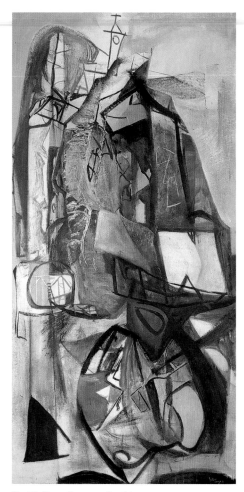

Fig. 19 Peter Lanyon, *Porthleven* 1951
Oil on board, 244.5 × 121.9 Tate

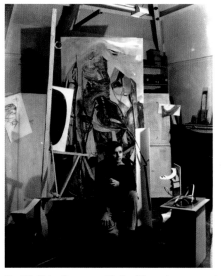

Fig. 20 Peter Lanyon with *Porthleven* in progress in his studio
Tate Gallery Archive

Fig. 21 John Minton, *Children by the Sea* 1945
Oil on canvas, 94.7 × 76 Tate

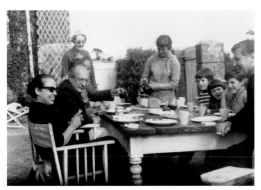

Fig. 22 Tea at Chapel Kerris 1959. Left to right, Meli Rothko,
Mark Rothko, Terry Frost (hidden), Marie Miles, June Feiler,
Helen Feiler, Christine Feiler, Anthony Feiler, Peter Lanyon.
Tate Gallery Archive

of a fisherman on the left and his waiting wife
on the right. For the artist, who was interested
in the Swiss psychiatrist Carl Jung and his theories
of the unconscious, these archetypal figures
embodied the cultural identity of his native land.
In 1955 he established the St Peter's Loft art
school with William Redgrave. Though aimed
at the art tourist market, it attracted serious
young painters impressed by Lanyon's escalating
reputation.

The 'St Ives School' justifiably gained post-war
acclaim for its humanising of pre-war abstraction.
This success was no doubt partly achieved
through the connection of its members to wider
art world structures. Despite its location, the
community of artists in St Ives was networked
to the national and international art establishment
through personal contacts. For example, Norman
Reid – a Tate Gallery curator from 1946, and its
director from 1964 to 1979 – was a close friend
of Hepworth's and became actively involved
in the Penwith, while Hepworth became a Tate
Trustee. The work of 'St Ives' artists also featured
in London galleries, where it was appraised
and sold.

Importantly, 'St Ives' benefited from dramatic
post-war changes in the structure of government
support for the arts. The Penwith Society
became a recipient of funding from the newly
established Arts Council, as it exemplified the
ideal of co-operation between advanced and
traditional art that lay at the heart of the Arts
Council's post-war programme of cultural
regeneration. Such funding ensured that the
Penwith Gallery could be staffed by professionals
like David Lewis, its first curator in the early
1950s. The idea of 'St Ives' was also heavily
promoted internationally by the British Council
as part of its post-war reassertion of national
culture abroad. For instance, Hepworth
represented Britain at the Venice Biennale
in 1950, followed by Nicholson in 1954.

Among the artists themselves, Nicholson,
Hepworth, Lanyon and Patrick Heron (art critic
of the New Statesman and Nation between 1947
and 1953) were key ambassadors for 'St Ives'
artists. A range of significant visitors came to St
Ives in the 1940s and 1950s. Members of London's
bohemia, such as the young Neo-Romantic
painters Robert Colquhoun, Robert McBryde

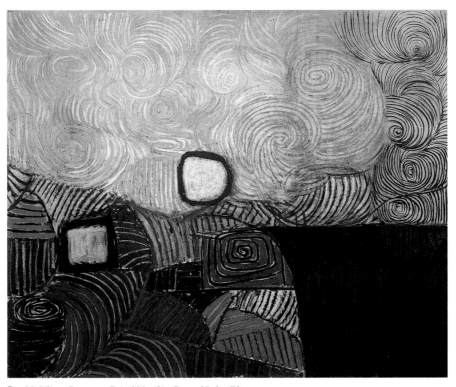

Fig. 23 Victor Pasmore, *Spiral Motif in Green, Violet, Blue and Gold: The Coast of the Inland Sea* 1950
Oil on canvas, 81.3 × 100.3 Tate

and John Minton, visited Cornwall during and after the war (fig. 21). Later visitors included, for example, artists Victor Pasmore, Francis Bacon, Mark Rothko and Mark Tobey, critic Clement Greenberg, art dealers Victor Waddington and Bertha Schaeffer, Lillian Somerville and Francis Watson of the British Council and Phillip James of the Arts Council. Despite its geographical remoteness St Ives became a place of international exchange. This process, initiated by Nicholson and Hepworth, was pursued by the younger artists through friendships and affinities with other artists. In August 1959, for example, Rothko made his now legendary visit to Lanyon, staying with him at Little Park Owles (fig. 22).

Back to Basics:
St Ives and Nature-based Abstraction

During the war, English visual culture – dominated by Neo-Romanticism and Euston Road Realism – had tended to reinforce and celebrate cohesive, traditional national values. In once sense, the revival of abstraction in the immediate post-war years might be seen as a response to this perceived hiatus in the progress of modern art. For example, London-based painter Victor Pasmore, whose evolution of an abstract style in the late 1940s was partly influenced by Nicholson, remarked that, 'in England, as in France, the war had put the clock back and an almost reactionary situation existed. Advances made in the 1930s by Moore, Nicholson, Hepworth and others had stopped in their tracks and a totally provincial attitude prevailed. After the war, therefore, my concern was more with getting back on the rails.'[6]

While visiting Nicholson in 1950, Pasmore produced drawings of Porthmeor Beach, which he used to develop subsequent abstract compositions (fig. 23). In 1951 he became associated with the emergence of a group of young constructionist artists in London, including Kenneth and Mary Martin, Anthony Hill, Adrian Heath and Robert Adams, who were pursuing geometric abstraction largely based on mathematical systems. For a while it was possible to present England's small band of abstract artists – whether in London or St Ives – collectively. For example, though recognising their differences, critic Lawrence Alloway's anthology *Nine Abstract Artists*, published by Tiranti in 1954, included Terry Frost,

Fig. 24 Roger Hilton, *January 1957*
Oil on canvas, 66 × 66 Tate

Fig. 25 Terry Frost, *Green, Black and White Movement* 1951
Oil on board, 177.8 × 101.6 Tate

Fig. 26 Alan Davie, *Black Mirror* 1952
Oil on board, 121.9 × 121.9 Tate

William Scott and Roger Hilton – all described as practising a kind of 'expressionistic action painting' – alongside the constructionists.[7]

Pasmore taught ex-serviceman Frost, who travelled between St Ives and Camberwell School of Art in the late 1940s. Settling in the town in 1950, he produced a body of work that experimented with abstract colour and form, while retaining some reference to the world. A key work, *Green, Black and White Movement* 1951, echoes the shapes of boats in the harbour, replacing literal representation with a sense of boat-associated swaying movements and rhythms (fig. 25). Along with other 'St Ives' artists, Frost was particularly interested in the work and ideas of Paul Klee, who explored the parallels between movement in space and the movement of a line on a page.

Frost, Lanyon and Wynter taught at the Bath Academy of Art in Corsham Court in the 1950s, where Senior Painting master William Scott and Head of Sculpture Kenneth Armitage endorsed a type of semi-abstraction derived from landscape or the figure. At Corsham, 'St Ives' artists became interested in the writings of gestalt psychologist Rudolf Arnheim. His idea of 'undifferentiated vision' encouraged them to paint in such a way that focused attention on the perception of light, space and air, rather on the picture surface.[8]

During the 1950s artists associated with 'St Ives' gained international recognition for developing a nature-based approach to abstraction. Yet, this preoccupation with nature was not simply a response to environment, but related to debates about modern art practice such as the idea of 'organicism', which gained currency at the time. 'Organicism' was informed by D'Arcy Wentworth Thompson's influential theory of the organic development of natural forms expounded in *On Growth and Form* (1917, second edition 1942). Its main advocate was Herbert Read, who promoted the idea that a work of art should evolve from a natural, organic process, to produce a unified, universal expression. So nature – with its given processes – was considered as a blueprint for art-making. Such thinking complemented the Arts and Crafts, truth-to-materials ethos of the older St Ives generation.

Shortly after the war and in the early 1950s there were ample opportunities for 'St Ives' artists to discover new trends in American painting. Alan Davie, for example, saw Jackson Pollock's work in Venice in 1948, while Lanyon saw Willem De Kooning's paintings there in 1950. Scott's exposure to American art in 1953 also made him an important conduit of international developments for his Cornish-based peers. Although aware of the new American painting, in the early to mid-1950s, 'St Ives' artists continued to look to Paris where a number of artists were pursuing 'tachisme', a form of painterly abstraction that emphasised the sensuous quality of the paint mark. They were particularly drawn to the work of Pierre Soulages, Nicholas de Stael and Sam Francis. London-based painter Roger Hilton had close contacts with European 'tachiste' artists. Although not moving to Cornwall until 1965, he made regular visits to St Ives, especially after his friend Patrick Heron settled at Zennor in 1956. His commitment to intuitive, instinctive painting – whether abstract or figurative – and his high regard for the physical presence of painting helped to shape 'St Ives' art (fig. 24).

Thanks to the presence of Frost, Lanyon, Heron and Wynter, the mid-1950s saw a further influx of artists into the area, including Brian Wall, Karl Weschke, Trevor Bell, Paul Feiler, Anthony Benjamin, Bob Law, Joe Tilson and Sandra Blow. Taking their lead from Lanyon, many of them developed a gestural, abstract style with references to sea and landscape.

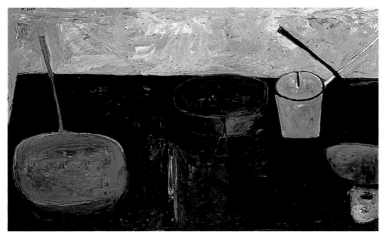

Fig. 27 William Scott, *Winter Still Life* 1956
Oil on canvas, 91.4 × 152.4 Tate

Fig. 28 Patrick Heron, *Harbour Window with Two Figures,*
St Ives: July 1950
Oil on board, 121.9 × 152.4 Tate

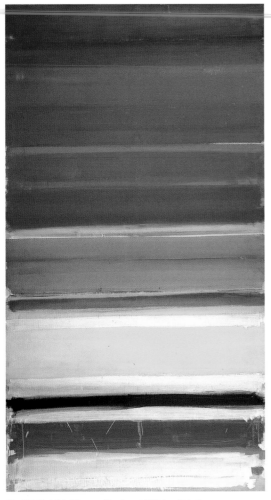

Fig. 29 Patrick Heron, *Horizontal Stripe Painting:
November 1957 – January 1958*
Oil on canvas, 274.3 × 154.8 Tate

While foreign travel remained problematic
after the war, it was possible to take holidays in
Cornwall, dubbed the 'English Riviera'. During
this period a number of British painters interested
in abstraction had productive visits to St Ives,
notably Adrian Heath and William Gear. Other
artists – musicians, designers, writers, and poets –
began to visit or relocate to the area, boosting
the image of St Ives as a modern art centre. Part
of the appeal of St Ives for young artists in the late
1950s and early 1960s was its libertine, Bohemian
reputation. Unlike the respectable colony of
earlier decades, many artists (like their Soho
counterparts) took drugs such as Benzedrine,
methadrine and cannabis to stimulate and unleash
creativity. Drinking alcohol – typically at The
Sloop, or Castle Inn – also provided a context for
interaction. The senior artists Nicholson, Leach
and Hepworth were not part of this macho, often
self-destructive, drinking culture.[9] Alcohol was to
claim the lives of a number of the artists associated
with St Ives, including Hilton.

'St Ives' and the International Scene
While the leading figures of 'St Ives' art in
the 1940s and early 1950s looked to European
modernism, in the later 1950s and 1960s the focus
shifted to America. In 1956 the Tate Gallery held
an exhibition of 'Modern Art in the United States',
which included one room dedicated to recent
abstract art. This was followed in 1959 by more
a comprehensive exhibition, *The New American
Painting*. The power of American abstraction,
its scale, expressive spontaneity and emotional
impact, signalled that New York had replaced
Paris as the centre of international art. Arguably,
the favourable response of European and British
abstract artists to the new American work –
especially in St Ives – paved the way for its wider,
positive reception.

The painters William Scott and Alan Davie
were aware of the new abstraction emerging
in the United States early on (**fig. 26**). Although
they never lived in St Ives, both were associated
with most of its artists. For Scott, contact with
American painters such as Jackson Pollock and
Mark Rothko in the mid-1950s served to highlight
the differences of their painting to his own:
'My personal reaction was to discontinue my
pursuit of abstract art and to try and put my earlier

form of symbolic realism on a larger scale than the easel picture, with a new freedom gained from my American visit. I now felt that there was a Europeanism that I belonged to' (fig. 27).[10] As the Americans gained international recognition, 'St Ives' art became known as a European form of abstraction that remained attached to nature as a primary source. In this regard it differed from American abstraction.

Through his critical writing – especially of the early 1950s – Patrick Heron played a key role in determining how 'St Ives' art was perceived, and in what terms it was discussed. He provided a sense of direction for 'St Ives' artists and positioned their work within an international context. In 1953 he selected an exhibition, *Space in Colour*, at the Hanover Gallery, London, which successfully drew attention to a group of emerging, experimental painters. Heron had spent part of his childhood in Cornwall and visited St Ives every summer from 1947 until the mid-1950s when he moved to Eagle's Nest, a house perched high on the coast near Zennor. In the early 1950s, his fascination with the work of the French modern masters Braque, Matisse and Bonnard led to a series of works exploring colour and form (fig. 28).

Heron's formalist ideas – the idea that the form or arrangement of an image provides its content or meaning – and his belief in the importance of pictorial space achieved through colour, were slightly at odds with the work other 'St Ives' artists, who were generally more interested in subjectivity and process. However, Heron's formalism coalesced with the views of American art critic Clement Greenberg, a key advocate of American Abstract Expressionism. Greenberg stayed with Heron at Eagle's Nest in July 1959. By the mid-1960s their friendship soured: Heron objected to Greenberg's views on American superiority and originality. Their disagreement came to a head in the 1970s when, contrary to Greenberg's claims, Heron had in fact produced a series of remarkable horizontal stripe paintings before the American artist Morris Louis (fig. 29).

Despite the increasing dominance of American painting on the international scene, 'St Ives' artists enjoyed considerable success in the United States. Lanyon, for example, held his first solo show in New York in 1957 at the Catherine Viviane Gallery, while Heron first showed in the city in 1960 at the Bertha Schaefer Gallery (fig. 30). Other artists associated with 'St Ives' including Davie, Frost and Scott also had exhibitions in New York, while Alexander McKenzie, John Wells, Paul Feiler and Denis Mitchell were included in American exhibitions.

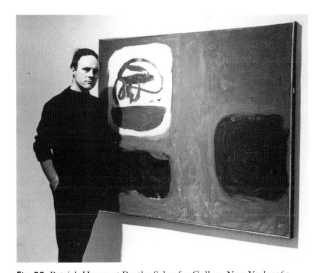

Fig. 30 Patrick Heron at Bertha Schaefer Gallery, New York 1962

Endings and Beginnings:
The Last Decade

By the 1960s the 'St Ives School' no longer represented the idea of a closely knit, regionally based art colony. Some of its most prominent artists, like Frost and Hilton, were often working elsewhere. Those remaining resident in or near the town, such as Heron, Lanyon and Wynter, were increasingly pursuing different aesthetic agendas. At the same time, a new wave of artists was emerging, including Karl Weschke, Alan Lowndes, and later Bryan Pearce, whose figurative work contrasted with the nature-based abstraction that defined the 'St Ives School'.

Views vary as to the duration of the 'St Ives School'. Ben Nicholson's departure for Switzerland in 1958 clearly marked the beginning of a gradual drift away from the town. Critical opinion also shifted. Reference to nature became increasingly viewed as a weakening of abstraction's integrity as an art form. In 1957, for example, influential art critic Lawrence Alloway cautioned: 'Landscape is the tender trap in England and it has caught a number of the abstract artists associated with St Ives'.[11] In 1960, Alloway was instrumental in organising *Situation* at the Royal Burlington Galleries, London. The exhibition promoted a new direction for British abstract art, that rejected any explicit reference to the world outside painting, and St Ives painters were notably excluded. By the 1960s, a growing fascination with man-made mass culture, and the rise of Pop art, which celebrated kitsch subject matter, further deflected critical attention away from 'St Ives' artists with their 'romantic' attachment to nature and abstraction.

Peter Lanyon's untimely death in 1964 was undoubtedly a watershed. However, his last works may have prompted new directions for some of his peers. Frost and Wynter, for example, may have learnt from his practice of making three-dimensional models as 'working constructions' for his paintings (**fig. 45**). Wynter recreated his floating brush marks as three-dimensional kinetic works in his *'IMOOS' (Images Moving Out Onto Space)* series (**fig. 32**), while from the late 1950s, Frost experimented with hanging objects, collage elements and painted sculpture. Although this play with unconventional materials was in tune with wider art practice in the mid-1960s, typically, 'St Ives' artists used these activities to inform their painting. For example, Wynter's kinetic works, which began as a way of extending perception of nature, later helped him to distil nature into two-dimensional form.

Throughout the 1950s and 1960s Hepworth remained a dominant figure in St Ives, where she continued to work despite the production difficulties caused by the increasing complexity and large scale of her work. Her special relationship with the town was acknowledged in 1968 when she was awarded – together with Bernard Leach – the Freedom of the Borough. The demise of St Ives as a vanguard art movement was hastened by 'external' events, notably the rise of Pop art, which stood in stark contrast to the rural escapism of 'St Ives'. But its end can be symbolically linked to Hepworth's tragic death in a fire at her studio in May 1975, which followed the deaths of Hilton and Wynter earlier that year. With these 'internal' events the notion of a post-war 'St Ives School' seemed to pass into history.

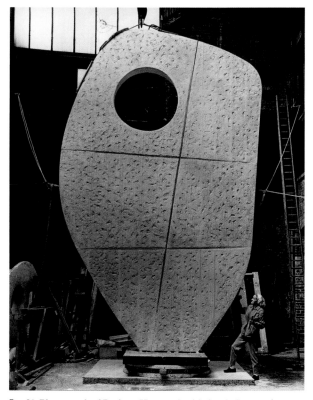

Fig. 31 Photograph of Barbara Hepworth with *Single Form* 1962–3
The New Art Centre, Salisbury

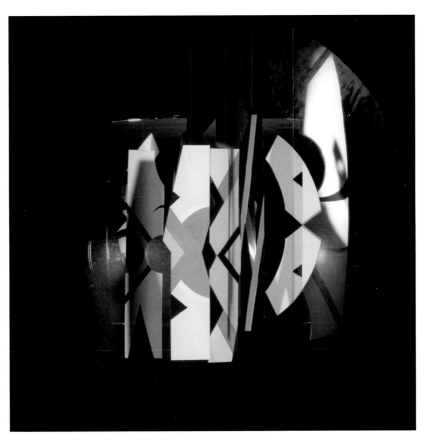

Fig. 32 Bryan Wynter, *Imoos VI* 1965
Gouache on card reconstructed, mirror and mixed media,
120.2 × 101 × 116.8 Tate

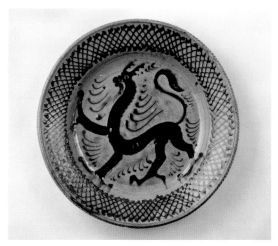

Fig. 33 *Dish* 1929
Earthenware with slip decoration, diameter 46 Tate

Born in Hong Kong, Leach drew on his knowledge of both western and eastern ceramic traditions to develop a modern vision of the artist-craftsman. His internationally renowned pottery, established in 1920, became synonymous with 'St Ives'. Leach's influence on the development of the twentieth-century studio pottery movement was unequalled, particularly through his sensitive understanding of oriental practices, emphasis on natural materials and design, and commitment to producing affordable, domestic ceramics compatible with modern living. From 1940 he practiced the Bahai'i faith, introduced to him by his friend, American artist Mark Tobey. His commitment to the hand-made, and deep knowledge of Eastern philosophies, dovetailed with the nature-based organicism of the 'St Ives School', and with post-war interest in mysticism and personal growth.

Trained as a painter and printmaker, in 1909 Leach travelled to Japan and China to learn about Eastern culture, earning a living by teaching etching. Before retuning to Britain in 1920, he had become an accomplished potter. Inspired by a group of young artists in Tokyo whose rediscovery of lost crafts chimed with the ideas of William Morris's Arts and Crafts movement, Leach dedicated himself to combining the sensibilities of the Far East with pre-industrial English ceramic traditions. A wealthy

philanthropist, Frances Horn, concerned with the lack of employment around St Ives, offered him capital to set up a pottery in St Ives with the help of his friend and fellow potter Shoji Hamada. Although not an ideal location, owing to the paucity of locally available materials such as timber and suitable clays, a three-chambered, wood-fired Japanese climbing kiln was constructed in 1923, the first of its type in the West.

Leach's project was ambitious. He was inexperienced, there was no established market, and run as a studio rather than workshop, the pottery valued artistry above productivity. Initially he made Raku earthenware, Korean stoneware and brown and cream slipware of the old Devonian and Staffordshire pottery. The heavy but functional *Dish* of 1929 shows Leach rejuvenating traditional English Galena slipware, its striking griffin motif referring to both English heraldry and Chinese or Japanese painting, while its dynamic draughtsmanship suggesting oriental artistry (**fig. 33**).

In 1932 Leach began teaching at Dartington Hall, where he established a workshop, while his son David ran the pottery in St Ives. During the war he returned to St Ives when David was called up for war service. He joined the Home Guard, and despite bomb-damage in 1941 the pottery kept going with the help of two conscientious objectors, one of whom was Patrick Heron. War conditions encouraged Leach to develop his idea of high fired 'standard ware' for domestic use – standard denoting consistency, availability and integrity – which became enormously popular in the post-war period (**fig. 34**). In 1955 Leach's sons David and Michael set up on their own, with management of the pottery in St Ives passing to his third wife, Janet in 1956. Over the years the Leach Pottery employed many assistants, some of whom founded their own potteries, such as Michael Cardew.

Fig. 34 *Standard Ware Mead Jug* 1940–59
Reduced stoneware, 19 × 13.5 × 13.5 Tate

Though born in Devonport, Wallis was identified as a Cornishman, his 'naive' paintings the expression of a true Celt. The retired seaman was known to such modern artists as Cedric Morris prior to his 'discovery' in 1928 by Ben Nicholson and Christopher Wood. But from this point on he was revered by England's avant-garde art community for the authenticity of his 'primitive' vision. After his death in 1942, Wallis became an iconic figure for artists of the 'St Ives School'. His disregard for the conventions of picture-making demonstrated the kind of powerful, individual creativity that they sought in their own work.

Starting out as a cabin boy, Wallis was later involved in the fishing trade between Penzance and Newfoundland. After his marriage to Susan Ward, twenty-years his senior, he became an inshore fisherman working on Mount's Bay luggers around 1880. They moved to St Ives in 1890 where he became a marine scrap merchant and in 1904 joined the Salvation Army. On his retirement in 1912 they moved to 3, Back Road West. Following the death of this wife, in the mid-1920s he began painting 'for company'. Through Wallis's open door, Nicholson and Wood spotted paintings nailed up over a wall. They found the old man inside and immediately acquired some of his paintings.

Wallis's subjects, painted from memory and observation, were mostly of St Ives, its lighthouse, boats and surrounding sea. His pictures are characteristically simple in composition and limited to a palette of mainly steely greys, greens and blues. He painted in household and boat paint on whatever materials were to hand, including odd-shaped wooden boards and card with pinholes. The peculiar physical properties of his supports are undisguised, and he often left substantial areas unpainted, allowing the support itself to form part of the picture, as clearly seen in *The Blue Ship* c.1934 (fig. 35). Together with his roughly applied paint, this conveyed a sense of immediacy and lack of pretension admired by modern painters. The palpable, hand-crafted nature of his works also drew attention to their identity as real objects.

In *The Blue Ship*, the sailor's memory of the vastness of the sea and scale of the ship's rigging overwhelms the other elements of the painting. Wallis's memories of a bygone life at sea appealed to nostalgic longings for the past, providing a link with an increasingly disappearing world. Some of his work dealt with more recent events, such as a series of paintings inspired by the tragic wreck of the Panamanian freighter *Alba* and the St Ives lifeboat on rocks off St Ives in 1938. He combined observation with information from news reports to produce works that transcend mere reportage to convey the futility of man's endeavour in the face of nature's power (fig. 36).

In the late 1930s he became increasingly eccentric and isolated, despite offers of support from friends. He died in Madron Institution, the local workhouse, in 1942, aged eighty-seven.

Fig. 35 *The Blue Ship* c.1934
Oil on board laid on wood, 43.8 × 55.9 Tate

Fig. 36 *Wreck of the Alba* c.1938–9
Oil on wood, 37.7 × 68.3 Tate

In 1930, in a state of opium-induced paranoia, twenty-nine year old Christopher or 'Kit' Wood threw himself under a train at Salisbury station. Admired by Picasso and Jean Cocteau, he was widely regarded as the most promising English modern painter of his generation. Constantly struggling to find his artistic voice, in Cornwall and Brittany Wood successfully developed a style of 'primitive', naive figuration, that combining fact and fiction imaginatively transformed elements of a real place to evoke its magical quality.

Born in Liverpool, he spent time in London before moving to Paris. The good-looking youth was quickly accepted in avant-garde circles. In 1926 he designed *Romeo and Juliet* for Diaghilev, made his first visit to St Ives, and met Ben and Winifred Nicholson in London. Painting together at the Nicholsons' home in Cumbria in spring 1928, they produced landscape and still-life pictures in a naive style, experimenting with Wood's technique of priming the canvas with household paint, which could be incised and scraped back to give a textured, visibly handcrafted surface. The Nicholsons' simple, disciplined lifestyle offered Wood respite from his hedonistic, peripatetic existence, while their marriage exemplified the stability he lacked in his own relationships.

As a foreigner working in Paris he became aware of his ethnic identity and sought ways to exploit this in his work. Keen to explore his Cornish/Celtic roots, he accompanied his friends to Cornwall in autumn 1928, where Alfred Wallis had a decisive impact on his work. Like Wallis, he began to combine fantasy, memory and observation, moving towards a personal symbolism derived from real experience. *The Fisherman's Farewell*, a family group – seemingly based on Ben, Winifred and their baby Jake – is foregrounded in the manner of a primitive holy family (fig. 37). While symbolising his yearnings for an ideal relationship, the picture also alludes to the life and death struggle of the fishermen, and implies a parallel between the modern artist and the simple yet heroic existence of the fishermen, who braved the sea to feed their families.

Cornwall offered Wood his best subjects and he visited other coastal regions for inspiration, travelling to Dieppe in 1929, and Brittany, where he spent his last two summers at the small fishing village of Treboul. He was particularly drawn to boats as symbols of life's adventure, vessels of the human soul, buffeted by powerful forces (fig. 38). The local traditions and visible Catholicism also focused his attention on themes of community, and of the place of spirituality in everyday experience. Typically, Wood experienced Brittany through memories of Cornwall, writing to Ben: 'The place is very like Cornwall which makes me want to be back there again with you'. He returned there for a few days in March 1930, staying at Mousehole, but was by now struggling with his addiction. Although the work made in Cornwall and Brittany justifies Wood's reputation, his tragic suicide has made it difficult to separate his achievement from his legend.

Fig. 37 *The Fisherman's Farewell* 1928
Oil on wood, 27.9 × 70 Tate

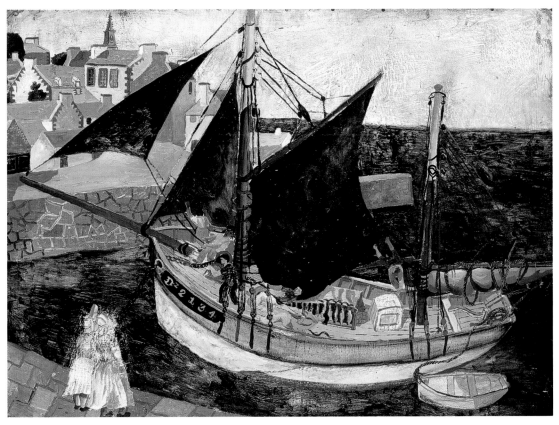

Fig. 38 *Boat in Harbour, Brittany* 1929
Oil on board, 79.4 × 108.6 Tate

Ben Nicholson 1894–1982

Active for over sixty years, Nicholson is recognised as England's pioneer modernist painter on account of his extraordinarily radical 'white reliefs' of the early 1930s. From the 1950s onwards he enjoyed international acclaim for his committed reworking of Cubism, which led to a fusion of abstraction and naturalism in his work. He was a tireless advocate of modern ideas through radical groupings; the Seven and Five Society in the 1920s, the Hampstead Set of the 1930s, and the 'St Ives School' in the 1940s and 1950s.

Nicholson experimented with modern idioms, notably Cubism and abstraction, using these visual languages to pursue an 'idea'. For him this involved the whole process of making a work, bringing together memory, experience and observation, through which he hoped to convey the spiritual reality underlying the world of appearances. Erroneously perceived as being too intellectual, he despised art-theorising and was committed to the notion of the instinctive artist.

Born in Buckinghamshire to painters Mabel Pryde and William Nicholson, he came to value his artistic inheritance. After studying briefly at the Slade, his career began in earnest when he married painter Winifred Roberts in 1920. He later married sculptor Barbara Hepworth with whom he spent twenty years from 1931 to 1951. His subsequent marriage to German photographer and journalist Felicitas Vogler in 1957 prompted Nicholson's move from St Ives to Switzerland in 1958, where he made a series of monumental reliefs. He returned to England in 1971, living in Cambridge, then London, where he died in 1982.

Nicholson lived in Cumbria, London, Switzerland, and made numerous working trips to Yorkshire, Brittany, Italy and Greece. But most important to him was Cornwall. On his first visit to St Ives in 1928, accompanied by Christopher Wood, he met 'primitive' painter Alfred Wallis, who made a lasting impression on his work. Moving to Cornwall before the outbreak of war in 1939, he lived at Carbis Bay and then St Ives from 1951 to 1958, playing a key role in the 'St Ives School'. In 1949 he secured one of the Porthmeor Studios, which allowed him to make larger work, including a mural commissioned for the Festival of Britain in 1951. In 1954 Nicholson

Fig. 39 *28 February 1953 (vertical seconds)* Oil on canvas, 75.6 × 41.9 Tate

represented Britain at the Venice Biennale and throughout the decade was garlanded with numerous international awards including the 1956 Guggenheim International Painting Prize.

In the 1950s Nicholson began to create intriguing, complex, rhythmic compositions that brought different aspects of his work – landscape, still-life, abstraction – together. For example, while *28 February 1953 (vertical seconds)* (**fig. 39**) of 1953 is an abstract composition of vertical forms, curved lines suggest mugs or glasses. A horizontal line reads as a table-top or horizon, conflating inside and outside space, studio and landscape. He developed these table-top compositions on a grand-scale, as for example, *August 1956 (Val d'Orcia)* of 1956 (**fig. 40**). Its horizontal format suggests the skylines of Europe's ancient cities, which he drew on his post-war travels. The coalition between the opposite styles of abstraction and naturalism, and sense of timelessness in Nicholson's work, appealed to post-war desires for reconciliation and certainty.

Fig. 40 *August 1956 (Val d'Orcia)* 1956
Oil, gesso and pencil on board, 122 × 213.5 Tate

A major figure in the history of modern art in England and internationally renowned, Hepworth played a pivotal role in the development of the 'St Ives School' in the 1940s and 1950s. During the inter-war years – along with friend and fellow sculptor Henry Moore – she explored the modern ideas of 'truth to materials' and direct carving, which led Hepworth towards abstract and biomorphic forms. Although diverse in form and content, her work is consistently sensitive to material, lyrically elegant and often rich in organic associations. Wartime experiences reinforced her socialist leanings, and despite post-war fame and the difficulty of producing large-scale works in bronze for prestigious public commissions, she remained devoted to the community of St Ives. In 1968 she was granted Honorary Freedom of the Borough of St Ives, and her tragic death in a fire at her studio shocked the town. In 1980 her studio became part of the Tate Gallery as the Barbara Hepworth Museum.

Born in Wakefield, she studied at Leeds School of Art, the Royal College of Art (1921–4), and lived in Italy from 1924 to 1926. She married the sculptor John Skeaping in 1925, and later Ben Nicholson, whom she met in 1931. Together they became key members of the Hampstead Set, establishing friendships with members of the Parisian avant-garde. In 1939 they moved with their young family to Cornwall, living in Carbis Bay until 1950. Hepworth moved to Trewyn Studio, St Ives, which she acquired in 1949, and the couple divorced in 1951. She represented Britain at the Venice Biennale in 1950, was awarded a CBE in 1958, and made DBE in 1965. She also served as a Trustee of the Tate Gallery from 1965 to 1972.

Hepworth's much celebrated Cornish landscape sculptures of the 1940s are equivalents of such landscape elements as caves, cliffs or prehistoric man-made forms. She commented: 'I cannot write anything about landscape without writing about the human figure and human spirit inhabiting the landscape. For me, the whole art of sculpture is the fusion of these two elements – the balance of sensation and evocation of man in this universe'. *Pelagos* of 1946 (meaning 'sea' in Greek) is a hollowed-out, spiral-shaped sculpture resembling a shell or wave (**fig. 41**). It was inspired by the view from her studio overlooking St Ives Bay, where two strips of land embrace the sea on either side. Its taut strings were intended to express 'the tension I felt between myself and the sea, the wind or the hills'.

After the war, Hepworth's repertoire of organic and human forms remained largely unchanged. The upright form appears in many variations in her work, often alluding to the human figure. The gently curved upright *Single Form* of 1961 was carved in wood following of the sudden death of her friend, United Nations Secretary General Dag Hammarskjold. They had been discussing a sculpture for the piazza in front of the new United Nations Headquarters in New York, and in 1964 a scaled up bronze version was unveiled there (**fig. 42**).

Fig. 41 *Pelagos* 1946
Part painted wood and strings, 43 × 46 × 38.5 Tate

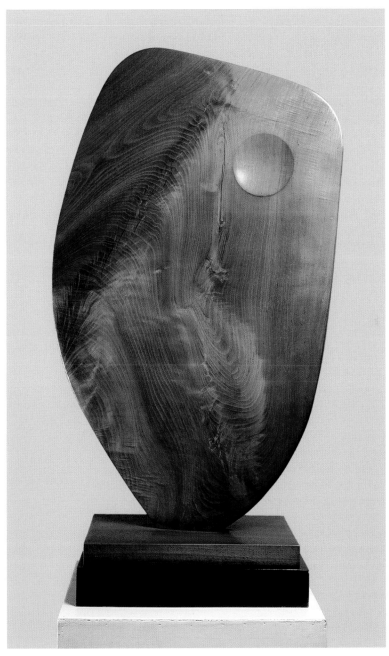

Fig. 42 *Single Form (September)* 1961
Wood, 82.5 × 50.8 × 5.7 Tate

Born in Russia as Naum Pevsner, Gabo became a leading exponent of constructivist or abstract art. His lifelong pursuit of pure form, involving a daring use of modern materials, was underpinned by his theoretical writings. Training in Munich, he spent the First World War in neutral Norway – where he changed his name to Gabo – returning to Russia in 1917. With Vladimir Tatlin, Wassily Kandinsky and Kasimir Malevich he became involved in the Russian Revolution, but after three years moved to Berlin. As a Russian Jew, Gabo decided to leave Germany for Paris in 1932, where he established an international reputation. In 1936 he settled in England, joining the circle of avant-garde artists, writers and émigrés in Hampstead.

In 1939, deeply troubled by the prospect of another war on the continent, Gabo and his wife, American painter Miriam Israels, followed Hepworth and Nicholson to Carbis Bay. They stayed there until departing for America in 1946. During his time in England Gabo produced an important series of works in transparent plastic, which allowed him to achieve a greater conceptual purity in his work. Although he was only in Cornwall during the war years, his work and theoretical ideas had a profound effect on Peter Lanyon, John Wells and Wilhelmina Barns-Graham, for whom he became a mentor.

In his ground-breaking *Realist Manifesto* of 1920 Gabo defined form in terms of space rather than mass, attempting to consider space as a sculptural element. In England he began to modify this view. Contributing to *Circle: International Survey of Constructive Art* (1937), he explored the idea of combining space and mass in sculpture to enrich their different properties through contrast. *Construction: Stone with a Collar*, conceived in Paris and made after the move to London, seems to embody his new thinking (**fig. 43**). His first use of direct carving, it combines irregular, asymmetric lines with geometric forms. The painted brass strip and sharp edge of the stone heightens the sense of space around it, while the softening of Gabo's geometric style indicates his aim to express the 'hidden forces of nature'.

Construction in Space with Crystalline Centre of 1938–40 (**fig. 44**) is one of a series of works that bring together external organic planes with a precise, rectilinear, crystalline centre, giving the effect of a self-contained core rotating in space. The elements of the work represent opposing energies of flowing momentum and internal, cell-like division held in balance. Here, Gabo utilises the transparency and flexibility of recently invented Perspex, and resolves his long-standing desire to express the hidden, dynamic interior of objects. His ideas influenced Hepworth, who photographed this work against the sea at Carbis Bay.

Living in reduced circumstances, Gabo soon ran out of modern materials. But eventually ICI provided a modest supply of plastics and he produced some key, smaller-scale works, including *Spiral Theme* of 1941, which, based on an idea from the mid-1930s, shows a new awareness of landscape. *Spiral Theme* became a seminal work for younger artists such as Peter Lanyon, who formed a close friendship with the Russian artist.

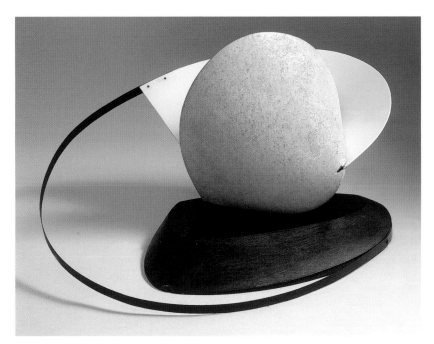

Fig. 43 *Construction: Stone with a Collar* 1933,
this version c. 1936–7
Stone, cellulose acetate, slate and brass, $37 \times 72 \times 55$ Tate

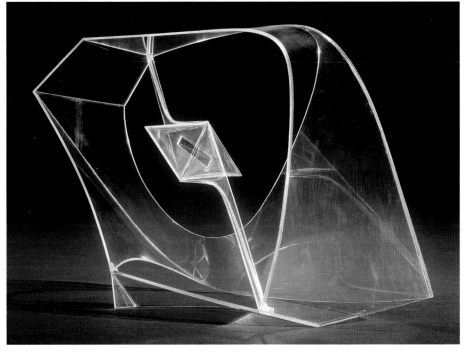

Fig. 44 *Construction in Space with Crystalline Centre* 1938–40
Perspex and celluloid, $32.4 \times 47 \times 22$ Tate

More than any other artist associated with the
'St Ives School', St Ives-born Lanyon consciously
strove to establish a regional art practice that dealt
with a particular place – its landscape, history,
culture, community and myths. Returning home
from service in the Royal Air Force during the
Second World War, he was admired by the senior
St Ives artists as the most talented painter of
his generation. Experience of war confirmed his
Cornish nationalist leanings and he came to regard
the internationalism promoted by Nicholson and
Hepworth as part of wider oppressive centralising
forces. By the early 1950s his desire to establish
a grittier, authentically regional art soured their
relations, although Gabo's influence on his work
remained profound.

Lanyon's long-term interest in painting the
'edge of landscape' – nature's ambiguous spaces,
or marginal zones – can be seen in early works
such as *Headland* of 1948, which focuses on cliffs
and sea, where land and water meet. During
the 1950s, interested in such theorists as Henri
Bergson, and exploring the creative potential
of his own bouts of depression, he began to test
the subjective nature of existence through the
spatial experience of the body, particularly in
the landscape.

A desire to record his experiential encounter
with places from every possible vantage point
prompted Lanyon to take up gliding in 1959,
'to get actually into the air itself to get a further
sense of depth and space into yourself, as it were,
into your own body, and then carry it through
into a painting'. *Lost Mine* of 1959, for example,
which refers to the tragic flooding of the Levant
tin mine, suggests a cloud-obscured landscape
glimpsed from above (**fig. 46**). Although adopting
the scale of American abstract painting, unlike his
American contemporaries Lanyon always referred
to the natural world, the Cornish landscape
remaining a primary source. Here, the cool palette
indicates the textures of iron and sea, while rapid
brushwork suggests the action of creative and
destructive forces.

Intrigued by Gabo's constructions, in 1939–40
Lanyon began making three-dimensional objects
to help him develop a sense of space in his pictures.
Often made from materials lying about the studio,
the most successful constructions were those
comprising pieces of glass stuck together with
black paint and glue, as their transparency was
compatible with the spatial ambiguity of his
paintings. In *Construction for 'Lost Mine'* of 1959,
the vertical axis of the construction, coated with
black, refers to the flooded mine shaft, while
the use of red, also seen in the final painting,
perhaps denotes danger and fatality (**fig. 45**).
Lanyon exhibited in New York in 1957, forming
a connection with several American artists
including Mark Rothko, who visited him briefly
in Cornwall in 1959. Both were drawn to the
romantic idea of the sublime and the vulnerability
and isolation of the individual in the post-war
world. Lanyon died on 31 August 1964 following
a gliding accident. His regional art had achieved
international recognition, and for many, his loss
signalled the end of the 'St Ives School'.

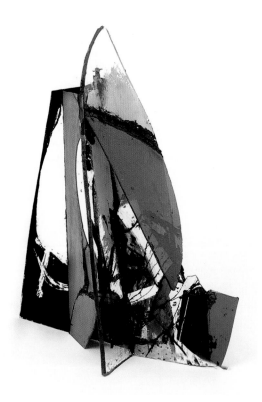

Fig. 45 *Construction for 'Lost Mine'* 1959
Glass, paint and Bostick, 53.8 × 48.3 × 27 Tate

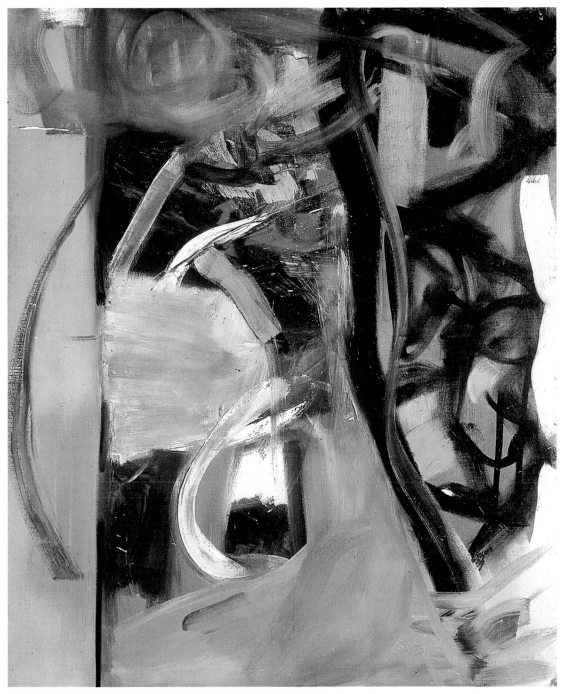

Fig. 46 *Lost Mine* 1959
Oil on canvas, 183.2 × 152.7 Tate

As a co-founder of the Crypt Group and Penwith Society, Wells contributed to the growing reputation of the 'St Ives School' in the 1940s. Training initially as a doctor, his exploration of inherent structures – from shell forms, rocks, flight patterns of birds and musical composition – drew both on his scientific knowledge and a deep, poetic appreciation of the natural environment. In this he was encouraged by Hepworth, Nicholson and Gabo, and especially by the latter's pursuit of pure form. For Wells, the fragile nature of cellular structure was particularly poignant, symbolising the fragility of human existence.

Born in London and growing up in Sussex, Wells made regular childhood visits to his mother's family home in St Meryan, Cornwall. He studied medicine at University College London, qualifying in 1930, but also pursued his interest in art, attending evening classes at St Martin's School of Art from 1927 to 1928. In 1928 he was invited to Feock in Cornwall by a cousin, where he met Ben and Winifred Nicholson and Christopher Wood, who were staying there with Marcus and Irene Brumwell. This contact was important for Wells, who kept in touch with Nicholson throughout the 1930s. From 1936 to 1945 Wells was a practising doctor on the Isles of Scilly. To counter feelings of isolation, he turned increasingly to painting and poetry, expressing his intense experience of nature and heightened awareness of the cycle of life in poems such as *Blue Time*, inspired by his boat trips between the islands. During the war, Nicholson and Hepworth introduced him to Gabo, and he developed a lifelong interest in the theories of constructive art. Moving to Newlyn after the war he dedicated himself to art practice.

Following the departure of their mentor Gabo in 1946, Wells and Lanyon developed a close friendship, often walking together in the landscape of west Penwith. Wells translated his encounters with nature into constructivist terms. In a series of paintings, including *Aspiring Forms* of 1950, he explored the flight of birds on air currents, their gliding movements articulating space in ever-changing formation above the static cliffs (**fig. 47**). Here, as in many other works, including one of his largest paintings, *Sacre du Printemps* of 1947–8, he used the proportions of the Golden Section – the division of a line so that the ratio of the smaller to the larger part is equal to that of the larger to the whole – as a starting point for his composition (**fig. 48**).

Between 1949 and 1951 he worked with Denis Mitchell, Peter Lanyon and Terry Frost as an assistant to Hepworth. He began to exhibit widely. The British Council, for example, included his work in *Salon des Réalités Nouvelles* in Paris in 1949. He held solo exhibitions at the Durlacher Gallery, New York in 1952, 1958 and 1960, and enjoyed his first solo show in London that year at Waddington Galleries. He was always diffident, however, and from the mid-1960s he decided to work more privately.

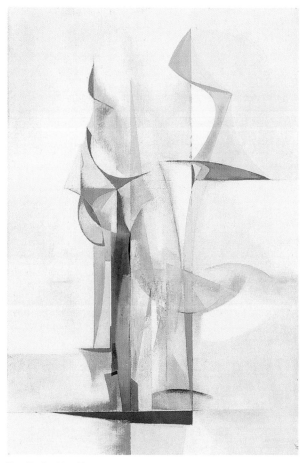

Fig. 47 *Aspiring Forms* 1950
Oil on board, 106.7 × 71.4 Tate

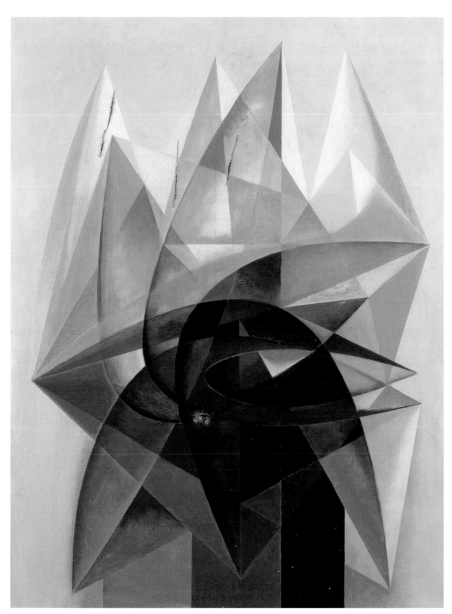

Fig. 48 *Sacre du Printemps* 1947–8
Oil on canvas, 121.9 × 91.4 Tate

Born in St Andrews, Barns-Graham studied painting at Edinburgh College of Art between 1932 and 1936. At the suggestion of her artist friend, Margaret Mellis, she moved to St Ives in Cornwall in 1940, where she soon became a member of the small group of artists gathering around Nicholson, Hepworth and Gabo. The first meetings of the Crypt Group were held in her studio and she became a founder member of the Penwith Society. Throughout her long career she often switched between abstraction and representation. Her main preoccupations were the dynamic contrast of forms, light, colour, space and a strong sense of the natural world, its rhythms and underlying structures.

Barns-Graham quickly won the respect of older artists, including Borlase Smart and the avant-garde émigrés from Hampstead. Nicholson and Hepworth provided the young artist with useful models of disciplined practice, while Nicholson, whose studio was next to hers at Porthmeor, shared ideas and offered advice. Importantly, Gabo encouraged her to explore the abstract energies contained in natural phenomena. Some time before 1946 she bought a small version of his transparent construction, *Spiral Theme* (1941) – a perfect demonstration of the dynamics of interior energy – which she kept in her studio.

Among her best-known works are a series of paintings, drawings and prints made over a four-year period resulting from a visit to the Glaciers at Grindelwald, Switzerland in 1948. These works explore the relationship between external form and internal energy, and suggest an overall experience of landscape. She later recalled that the spectacle of the Upper Glacier – its massive and fantastical crystalline forms, the effects of refracted light and colour, the contrast between the glacier's solidity and glassy transparency and its constant movement – prompted her in *Glacier Crystal, Grindelwald* of 1950 to 'combine all angles at once, from above, through, and all around, as a bird flies, a total experience' (**fig. 50**). She had met Professor d'Arcy Wentworth Thompson in St Andrews before the war, and, with other 'St Ives' artists, was familiar with his theory of the organic development of natural forms as outlined in *On Growth and Form*. The Glacier paintings were the first in which she attempted to mimic – through her actual approach to picture-making – the natural processes that had shaped their forms.

In addition to her nature-based abstractions, Barns-Graham made paintings that relied not so much on natural sources, but on the visual language of painting such as composition, colour and texture. For example, in *Red Form* of 1954, using the proportions of the Golden Section, the artist set out to investigate how a form might be perceived in space when placed against an ambiguous, unanchored background (**fig. 49**).

In 1956–7 she taught at Leeds College of Art and took a studio in London in 1961, returning to St Ives in 1963. From the early 1970s she began to spend more time in Scotland and for the rest of her life divided her time between St Andrews and St Ives.

Fig. 49 *Red Form* 1954
Oil and pencil on board, 34 × 41.9 Tate

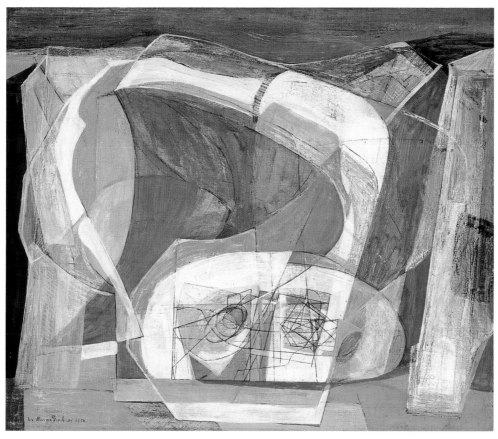

Fig. 50 *Glacier Crystal, Grindelwald* 1950
Oil on canvas, 51.4 × 60.9 Tate

Wynter arrived in Cornwall in 1945 and quickly became involved with the community of modern-minded artists living in or around St Ives. Though co-founding the Crypt Group and joining the Penwith Society, he remained detached from the rivalries that defined the 'St Ives School'. A close friend of Patrick Heron (whom he knew before the war) and Roger Hilton, Wynter belonged to the so-called middle generation of 'St Ives' artists who established reputations in the 1950s, mostly through the pursuit of large-scale, painterly, nature-based abstraction and a shared interest in organic processes.

Born in London, Wynter started out in the family laundry business, training in the profession in Zurich before his father eventually allowed him to attend the Slade School of Art in 1938. Like many 'St Ives' artists his early career was interrupted by the Second World War. Registering as a conscientious objector on humanitarian grounds, he spent the war in Oxford, working on drainage, and tending laboratory animals in the Department of Human Anatomy at Oxford University, a depressing experience which increased his feelings of alienation. Aldous Huxley's *Ends and Means* (1937), which expressed the idea of social reform through personal development and spirituality, inspired his migration to Cornwall, a place nostalgically remembered from childhood holidays.

For the next twenty years Wynter lived a simple, relatively isolated existence at Carn Cottage on the moors high above Zennor, interspersed by contact with local artists, poets – especially W.S. Graham – and bohemian London. The wild, ancient area of land between St Ives and Land's End remained a primary source for his work. He immersed himself in this landscape, avidly exploring its physical properties, which for him offered a kind of transcendence. Curious to get beneath surface appearances, Wynter's understanding of nature invariably reflected his preoccupation with questions of human existence.

During his first decade in Cornwall, his small-scale, Neo-Romantic-style works focused on such typical Cornish subjects as gulls, boats and abandoned tin mines, often suggesting themes of death and decay. In the mid-1950s he taught

Fig. 51 *Mars Ascends* 1956
Oil on canvas, 152.7 × 101.3 Tate

part-time at Bath Academy of Art at Corsham Court, after which he began to paint large canvases of layered, abstract forms, for example *Mars Ascends* of 1956, which suggests deep space, exploring his interest in organic processes and the collective unconscious (fig. 51). In this painting he followed the scientific theory of the growth of organic forms, placing each brush-mark in relation to the preceding marks so that the image evolved naturally from his subconscious. In the 1960s he also developed a series of illusionistic mobiles known as '*IMOOS' (Images Moving Out Onto Space)* – which like Kinetic and Op art experimented with the nature of visual perception.

Ever the explorer, Wynter canoed on the rivers and streams of Cornwall and around the rocky coastline from St Ives to Land's End, translating his experiences in a series of late 'hard-edge' paintings on the theme of water and its movement (fig. 52). Suffering from a heart condition, he died suddenly on 11 February 1975.

Fig. 52 *Meander 1* 1967
Oil on canvas, 168 × 213.4 Tate

Terry Frost became one of the best-known – and perhaps best-loved – artists associated with St Ives. Aiming to convey a moment of pure joy or 'moment of truth', Frost's abstract images exude a feeling of optimism. His work often explores the relationship between order and chaos, using the discipline of constructivist abstraction to harness his subjective experience of the world. Frost's philosophical approach to picture-making – inspired by Matisse's advice to always think 'that was the best time' – was formed during the Second World War, when as a P.O.W. in 1943 he was encouraged by fellow prisoner, abstract painter Adrian Heath, to begin painting. The experience of war convinced Frost – along with other artists of his generation – of the restorative power of art.

Frost came from a working class background and rather than interrupting his career as an artist, the war allowed him to become one. Born in Leamington Spa, Warwickshire, he attended evening classes at the age of sixteen and was variously employed until, as a member of the Territorial Army, he was called up in 1939. Captured in Crete in 1941, he spent most of the war imprisoned in Bavaria. In 1946, on Heath's suggestion, he moved to St Ives, attending the St Ives School of Painting until an ex-serviceman's training grant enabled him to study in London at Camberwell School of Art (1947–50), where Victor Pasmore became his mentor. He joined the Penwith Society in 1950, worked for Hepworth between 1950 and 1952, and then taught at the Bath Academy, Corsham, for two years. He held his first solo show in New York at the Bertha Schaefer Gallery in 1960.

In 1950 Frost began a series of works inspired by daily walks in St Ives' harbour, which capture the rocking motion of moored boats and the gentle roll of waves coming into shore. The first of this series, which continued to 1954, was *Green, Black and White Movement* of 1951 (**fig. 25**), in which Frost used the geometric proportions of the Golden Section to give abstract structure to the picturesque subject of boats in a harbour. Between 1954 and 1956 he was Gregory Fellow in Painting at Leeds University and taught at Leeds College of Art from 1956 to 1959. *Yellow Triptych 1957–9* echoes the grand scale of the Yorkshire Dales, which the artist found more imposing than the landscape of Penwith, and indicates his awareness of contemporary American abstraction painting (**fig. 54**).

During the 1960s, he refined his use of colour and form, developing a vocabulary of strong, distinctive shapes based on signs and flags, perhaps in response to Ellsworth Kelly's shaped, single colour canvases, which he might have seen in America. Though ostensibly abstract, his images continued to refer to real objects such as boats or the female form, such as *June, Red and Black* 1965, which for the artist evoked film-star Mae West's famously curvy figure (**fig. 53**). Frost left St Ives for Banbury in 1963, returning to Cornwall in 1974, where he lived in Newlyn until his death.

Fig. 53 *June, Red and Black* 1965
Acrylic on canvas, 244.5 × 183.5 Tate

Fig. 54 *Yellow Triptych* 1957–9
Oil on board, 228.6 × 365.7 Tate

Though recognised as a major artist of the 'St Ives School'– praised for his inventiveness and originality – Hilton's work resists any easy classification of 'St Ives' art. Through his friendship with Heron he made his first visit to the area as late as 1956. Thereafter, he spent a number of summers in Cornwall, yet in many ways he resolutely remained a metropolitan artist. In 1965, with his second wife, the painter Rose Hilton, he reluctantly settled at Botallack Moor. Unlike many of his peers, his main inspiration and primary subject was not the landscape, but the human figure. Conscious of the momentous cultural shifts taking place as a result of the Second World War, he set himself the task of inventing a new kind of figurative painting – involving both abstraction and representation – expressive of contemporary human experience. In 1961 he asserted: 'Abstraction has been due not so much to a positive thing but to the absence of a valid image. Abstraction in itself is nothing. It is only a step towards a new figuration, that is, one which is more true'.

Born in Middlesex as Roger Hildesheim – the family surname was changed in 1916 in response to anti-German feeling during the First World War – Hilton attended the Slade School of Art between 1929 and 1931. During the 1930s he periodically attended the Académie Ranson in Paris, under French tachiste painter Roger Bissière. When war broke out he joined the army, volunteering as a commando. He was captured in 1942, becoming a P.O.W. until the end of the war, an experience that attuned him to the darker side of human nature. After the war he experimented with abstraction, notably with geometric 'Neo-Plasticism', exemplified by Piet Mondrian. In 1953 he met Dutch painter Constant (Constant A. Nieuwenhuys), whose commitment to the role of intuition in the creative process had an immediate impact on his practice. Subsequently, Hilton's work was imbued with a human presence and sensuality regardless of its subject matter, such as *February 1954* which comprises irregular, expressive abstract forms evocative of the human figure (**fig. 55**).

After 1956, Hilton began drawing with charcoal into and over his paint, a technique that heightened the expressive, energetic and improvisatory quality of his work. In the 1960s and 1970s he produced remarkable – often voyeuristic and eroticised – images of women which visualise the sense of touch. Using distortion and expressive line he intimately suggests how a body might feel when caressed. One of his most overtly vibrant and joyous celebrations of the female form is *Oi Yoi Yoi* of 1963 (**fig. 56**).

Hilton was awarded the UNESCO prize at the Venice Biennale in 1964 and a CBE in 1968. Excessive alcohol consumption led to the deterioration of his health and from 1972 he was confined to bed, where he produced an extraordinary body of work comprising gouaches, drawings and notes known as the *Night Letters*.

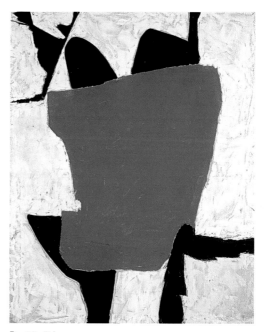

Fig. 55 *February 1954*
Oil on canvas, 127 × 101.6 Tate

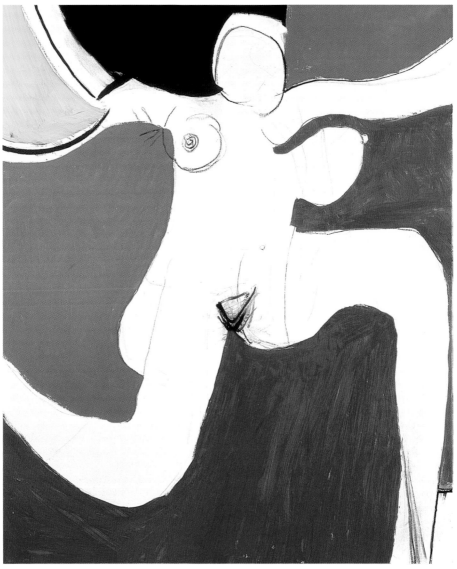

Fig. 56 *Oi Yoi Yoi* 1963
Oil and charcoal on canvas, 152.4 × 127 Tate

Through his eloquent critical writing and personal contacts, Heron was a key advocate of the 'St Ives' artists, creating a critical context for discussion of their work. Whether supportive or critical, his assessments were underpinned by a belief in the significance of their work, both nationally and internationally. Although he embraced the scale and energy of post-war American abstract painting, his ongoing exploration of space and colour – and the formal concerns of painting – were nourished by a dialogue with French modern masters, notably Georges Braque, Henri Matisse and Pierre Bonnard. During the mid-1950s he developed a purely abstract idiom, but his preoccupation with creating the illusion of space through colour – while remaining truthful to the two-dimensional surface of a painting – made him particularly sensitive to the 'quality of light' on the Penwith peninsula surrounded by light-reflecting expanses of water.

Heron was born in Leeds but had a strong childhood connection with Penwith. Between 1925 and 1930 his father managed Crysede Silks, a textile firm in Cornwall, before establishing the highly successful Cresta Silks in Welwyn Garden City. At school in St Ives Heron made friends with Lanyon, and during the winter of 1927–8 his family lived at Eagle's Nest, a house remotely located on the cliffs at Zennor, which Heron subsequently bought in 1955. He attended the Slade School of Art part-time between 1937 and 1939, meeting Wynter, who became a life-long friend. Heron's family were pacifists and at the outbreak of war he registered as a conscientious objector, serving as an agricultural labourer before being posted to assist at the Leach pottery at St Ives.

After the war Heron lived in London, regularly spending summers in St Ives until settling at Eagle's Nest. While pursing his career as a painter he became an authoritative art critic, writing for *New English Weekly* (1945–7), the New Statesman and Nation (1947–50), and later as London correspondent for *Arts*, New York (1955–8). He was also involved in selecting such significant exhibitions as the Hanover Gallery's *Space in Colour* of 1953. Moving from representational to abstract work in the mid-1950s, Heron sought to create pure, visual sensations through paint, such as *Azalea Garden: May 1956*, one of a series inspired by his garden, with its 'effervescence of flowering azaleas and camellias' (**fig. 57**). In 1957 he began a series of non-figurative horizontal stripe paintings, some years before those made by American abstract painter Morris Louis, which focused attention on 'the experiences of colour itself'.

When Nicholson left St Ives in 1958 he suggested that Heron take over his spacious Porthmeor studio, which allowed the production of larger paintings. In the late 1960s Heron made a series of very large paintings such as *Cadmium with Violet, Scarlet, Emerald, Lemon and Venetian: 1969*, in which he tested the impact of scale on compositional design and the effects of creating a large scale 'field of physical sensation' through vibrating colour (**fig. 58**). He was awarded a CBE in 1977 and served as a Tate Trustee from 1980 to 1987.

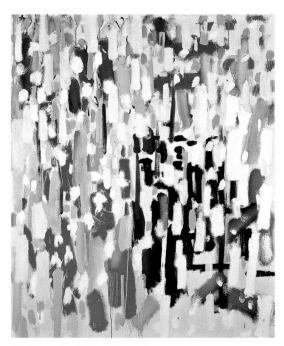

Fig. 57 *Azalea Garden: May 1956*
Oil on canvas, 152.4 × 127.6 Tate

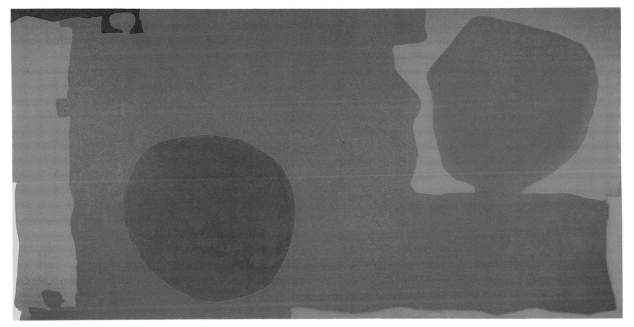

Fig. 58 *Cadmium with Violet, Scarlet, Emerald, Lemon and*
Venetian: 1969
Oil on canvas, 198.5 × 379 Tate

Aiming to support themselves by market gardening, aspiring young painters Denis and Endell Mitchell moved to St Ives in 1930. Initially, Denis produced landscape paintings in his spare time under the influence of John Park at the St Ives Society of Artists. Through his friendship with Bernard Leach he got to know the artists from Hampstead, who introduced him to modernist ideas and practices, notably 'truth to materials' and the constructivist preoccupation with open forms, space and light. Nicholson became a supportive friend and mentor. While working closely with Hepworth at Trewyn Studios as her longest serving assistant between 1949 and 1959, Mitchell gradually evolved from being a figurative painter to a sculptor of abstract forms. Hepworth's tutelage allowed him to hone his craft and to establish his own clearly defined interests, namely, the pursuit of universal forms derived from formal and philosophical enquiries in response to landscape. Characteristically diplomatic, as a founder member of the Penwith Society and later as chairman (1955–7) he played a significant role in the emergence of the 'St Ives School'.

Born in Middlesex, Mitchell grew up in Mumbles, Swansea. Although by 1930 he was attending evening classes at Swansea School of Art, the invitation to renovate an aunt's house in Balnoon, near St Ives, prompted the Mitchell brothers move to the artists' colony. Working on the land instilled Mitchell with a strong sense of being in a landscape, while his service in Geevor tin mine, St Just, during the Second World War provided a different perspective. His subsequent preoccupation with ascending, transcendental forms relates to the spiritual experience of singing hymns in underground caverns before rising upwards to daylight. Labouring underground was also humbling, and no doubt influenced his pursuit of universal forms and commitment to integrity in his creative process.

At Trewyn, Mitchell experimented with different techniques and materials, such as slate, board, iron, brass and wood. By the time he left he was producing a series of vertical, single-form sculptures in polished bronze, for example *Turning Form* of 1959, which, referring to Wells's painting *Aspiring Forms* of 1950, explores the potential of polished bronze to create an interplay of line, space, light and form (**fig. 59**). *Turning Form* was sand-cast in solid bronze, a process which produces simple shapes and requires a time-consuming, laborious hand-finish to achieve a perfect, light-reflecting surface. This commitment to an intuitive working of the surface – inherited from Hepworth – made each cast unique.

Mitchell's sculptures of the 1960s often represent figures or suggest tools – of gardening, mining, fishing, carving – as if equating the artist with simple, honest labour. His use of asymmetry, and acute sense of balance between line and form, aimed to convey a sense of innate vitality. This is clearly demonstrated by *Praze* of 1964, a highly accomplished, streamlined form, its powerful suggestion of ascending movement evoking Mitchell's transcendental experience of rising up from the depths (**fig. 60**). In 1967 he joined Marjorie Parr Galleries, which allowed him to practice sculpture full time. For the next twenty-five years he shared Trewarveneth Studio, Newlyn, with John Wells.

Fig. 59 *Turning Form* 1959
Bronze, 164 × 27 × 31 cm Tate

Fig. 60 *Praze* 1964
Bronze, 191.8 × 27.9 × 28.6 cm Tate

Fig. 61 *Inclined Oval Brown* 1964–5
Oil on canvas, 91.4 × 101.6 Tate

Abstract painter Paul Feiler has worked in
Cornwall for more than fifty years. Although
playing a peripheral role in the development
of the 'St Ives School', his close friendship with
'St Ives' artists, notably Lanyon and Wynter, and
his pursuit of a nature-based abstraction, justify
his inclusion here. The spatial ambiguities and
perceptual distortions he experienced as a child
while climbing and skiing in the snow-covered
Bavarian Alps kindled a life-long preoccupation
with the experience of space as perceived in the
landscape. His interest in exploring the sensation
of being in the landscape, rather than viewing
it from a fixed point, has led to a body of work
that conveys the ambiguity of spatial experience
produced by the particular quality of light
in Penwith.

Feiler was born in Frankfurt am Main. He
came to England in 1933 and from 1936 to 1939
attended the Slade School of Art where he became
friends with Wynter. During the war he was
interned in Canada between 1940 and 1941. On
his return to England he taught at the Combined
Colleges of Eastbourne and Radley and from 1946
at the West of England College of Art, Bristol,
where he was Head of Painting from 1963 to 1975.

During the 1950s and 1960s, although his
work was influenced by American Abstract
Expressionism, it always relied on an engagement
with the external world, particularly the experience
of light. His thickly painted abstractions of the
1950s – which relate to the textured surfaces
produced by such contemporaries as William
Scott, Peter Lanyon and French artist Nicolas de
Stael – are produced in a palette of greys, blacks,
whites, greens and blues that suggest the Cornish
landscape. Feiler's attention to compositional
structure became increasingly important, as
demonstrated by *Portheras Grey* of 1959–61,
which – prompted by encounters with the cliffs
of the Penwith peninsula – is dominated by
strong vertical and horizontal lines framing
a soft, central area of white paint, evoking light
and space (**fig. 62**).

In the 1960s he began a new series of work
characterised by strong, simple structures and
austere colour. Though still thickly textured
and referring to landscape – to such elements
as boulders, fields and cliffs – the forms in these
paintings, as for example in *Inclined Oval Brown*
of 1964–5, became increasingly pared down and
geometric, indicating his desire at this time to
respond to landscape in abstract terms (**fig. 61**).

These works led Feiler in the later 1960s and
1970s to develop a more universal visual language
to express the limits of vision and the elusive
nature of space. To achieve this he relinquished
his gestural, textured application of paint for
quieter, almost invisible brushwork, while his
imagery suggests the idea of an inaccessible
enclosure, suspended in space and perceived
from a distance.

Fig. 62 *Portheras Grey* 1959–61
Oil on canvas, 91.7 × 132.5 Tate

Bell arrived in St Ives in 1955 on an old motorcycle. He was attracted to the artist's colony by the work of the middle generation – Lanyon, Heron, Wynter, Hilton and Frost. He stayed for only five years, during which time, on the occasion of his first solo exhibition at Waddington Galleries, London in 1958, Heron declared him 'the best non-figurative painter under thirty' working in Britain. The show sold out even before it opened. Although not considering himself a 'St Ives' artist, it can be argued that Bell's formative experience in Penwith prepared the ground for the subsequent themes in his work. These include a continued reference to landscape, nature and external sources, formal experimentation with the structure of the canvas and its presence as an object, and a desire to convey a sense of spirituality.

Born in Leeds, Bell studied at Leeds College of Art (1947–52), teaching at Harrogate Art College before his meeting with Frost at Leeds in 1955 determined the move to St Ives. Renting at cottage at Tregerthen, Zennor, next door to Karl Weschke, he later moved to Nancledra (Roger Hilton's future home) and shared a studio with Brian Wall in a basement of the Seaman's Missions. In 1956 he joined the Penwith Society. In Cornwall his northern industrial landscapes gave way to mainly semi-abstract paintings that evoked a sense of landscape, focusing on the meeting of natural forces – waves breaking on the shore – and such natural structures as fields and cliffs.

Typically, his intuitive use of colour and form produced a shallow pictorial space of the kind that resonated both with Heron's theoretical position and Hilton's approach to practice. He also expressed his experience of the ocean's expansiveness while sailing at night – the tension between its velvety blackness and lights on the shore – in the same terms as the poet W.S. Graham, whose *The Nightfishing* was regarded as a meditation on 'being'.

In 1960 he was offered the Gregory Fellowship at Leeds University, and stayed in the North of England until the early 1970s. Following his highly successful touring show initiated by the Richard Demarco Gallery, Edinburgh in 1970, and at the Whitechapel Art Gallery in 1973 he settled in Tallahassee, Florida, finally returning to live and work in Penwith in 1996.

By the end of the 1960s he had established a distinctive and at the time, radical, visual language, which, using unconventionally shaped and bevelled canvases, pushed his painting to the verge of sculpture, while retaining their reference to being in the world. Playing with the relationship between art work and its architectural surroundings – making walls and floors actively part of the work – he created new relationships between the work and the viewer (**fig. 64**). That these concerns evolved over the decade is indicated by *Overcast*, an accomplished painting of 1962 that in the artist's words conveys the 'strangeness and power' of Northern imagery, while creating through juxtaposition of forms '… a sort of presence or environment, completely inter-related but demanding decisions from the viewer as the point of departure' (**fig. 63**).

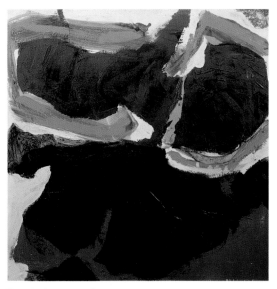

Fig. 63 *Overcast* 1961
Oil on canvas, 61 × 61 Tate

Fig. 64 *Calshot* 1970
Acrylic on canvas, 203 × 320 Collection of the artist

Weschke lived in Cornwall for over fifty years. For much of that time he isolated himself in a cottage at Cape Cornwall, a dramatic, austere location framed by desolate moorland and the Atlantic Ocean, exposed to wind and sky. His powerful, often brooding and melancholic paintings – mainly of figures, animals and landscape – drew on this extreme and unforgiving environment. Throughout his career, he transformed real experiences into images of universal significance, exploring such existential themes as struggle and alienation, themes prompted by memories of war and its aftermath.

Erroneously categorised as an expressionist on account of the emotional intensity of his work – and no doubt because of his German identity – his concern was to 'provoke' a sense of recognition, rather than to express heightened emotion, an approach perhaps best described by critic John Berger in the late 1950s as a 'passionate identification' with his subjects. His friendship with such 'St Ives' artists as Wynter, Hilton and Lanyon, and his emphasis on direct experience – on a subjective, experiential approach to the landscape theme – links him with other 'St Ives' artists. Although he was conscious of his identity as an outsider he joined the Penwith Society in 1957.

Weschke's childhood was deprived and unhappy. Born in Taubenpreskeln, near Gera, Germany, he joined the Hitler Youth and in 1942, aged only sixteen, volunteered as a paratrooper in the Luftwaffe. Wounded in 1945 and taken prisoner, he was rehabilitated in P.O.W. camps around Britain until 1948. Horrified by his formative experiences, and disgusted by his homeland, he decided to stay in England and become an artist. In 1949 he attended St Martins School of Art for one term, and spent time in Scotland, Spain and Sweden before moving to Zennor in 1955, encouraged by Bryan Wynter. His early paintings were mostly thickly painted, sombre semi-abstract landscapes, redolent – as a contemporary critic noted – with the 'fears and sorrows of our civilisation'.

In 1960 he moved to Cape Cornwall. Using a combination of washes of paint and line, he began producing his images through a process of accretion. Solitary figures, both human and animal, often pictured in moments of duress, began to feature more prominently in his work. His treatment of the theme of violation remained characteristically un-judgmental. Ambiguity between aggressor and protector is particularly evident in Weschke's images of dogs, such as *Feeding Dog* of 1976–7, which powerfully suggests the struggle for survival (**fig. 66**).

In the 1990s he was able to visit Egypt on several occasions. There he was struck, not by the light, but by a sense of colour as substance, while for him Egypt's ancient sites provided evidence of the futility of man's endeavours in the face of nature. Although impressed by the grandeur of the antiquities, he was deeply affected by the vastness and ruthless power of the desert. In *The Nile Near Kom Ombo* of 1994, for example, human presence is merely suggested by a few lines on the landscape (**fig. 65**).

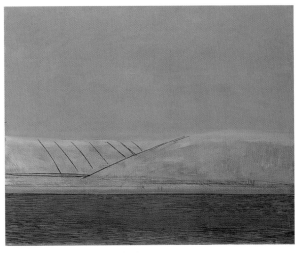

Fig. 65 *The Nile near Kom Ombo* 1994
Oil and charcoal on canvas, 142 × 178 Tate

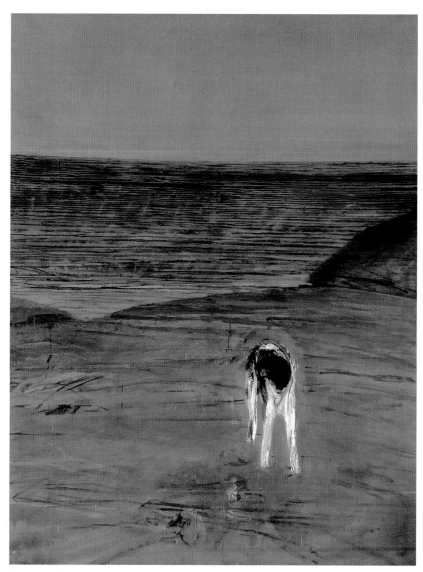

Fig. 66 *Feeding Dog* 1976–7
Oil on canvas, 197.7 × 152.3 Tate

St Ives and its environs were more than the subject of Bryan Pearce's art for over fifty years: they were his entire world, a world of subtle harmonies, stillness and tranquility, intensely observed and lovingly pictured from memory and imagination. As a child he developed phenylketonuria, a mental condition that inhibited his ability to have normal communication with others. This enforced solitude produced the conditions for the life of an artist, allowing him to dedicate himself to his work. At the same time, it gave him a heightened awareness of things, and a freedom from artistic conventions or expectations.

As a visionary or 'primitive' he has sometimes been compared with Alfred Wallis. Unlike Wallis, however, he lacked any critical consciousness with regard to his work. While Wallis's images of place are often imbued with a sense of longing for a lost world through their reference to dramatic events or incidents, by contrast, Pearce's vision of St Ives is that of a beautiful, untroubled, eternal present, in which all elements are given equal attention.

Pearce was born in St Ives in 1929. His family were well established in the town where they had been butchers since the eighteenth century. Encouraged by his mother, the artist Mary Pearce, he began painting in his early twenties. Pearce attended the St Ives School of Painting under Leonard Fuller between 1954 and 1957, yet remained uninterested in the work of other artists.

His condition made him impervious to outside influences. Initially he painted in watercolour, then from 1957 in oils, which allowed him to develop the decorative flatness and remarkable evenness of tone characteristic of his pictures. In that year he also joined the Penwith Society. Until the last decade of his life he would walk around the town, usually after breakfast and in the afternoon, absorbing his surroundings. Typically, from the late 1950s onwards, he would start a painting by drawing an image in outline in front of the motif. Later in the studio he would often paint over the outline in yellow ochre, increasing the celestial luminosity of his pictures.

Particularly distinctive are Pearce's 'all-round' views of St Ives harbour, such as *St Ives Harbour (all round) No.4* of 1966, which show little regard for conventional perspective (**fig. 69**). Even when depicting panoramic or multiple vistas, Pearce's images celebrate the mundane and particular through meticulous attention to even the smallest detail, such as individual stones, slates and railings. Whether painting domestic objects, vases of flowers, St Ives harbour with fishing boats, the island promontory, the cemetery, St Ia Church or the stacked houses of Downalong, he conveys a sense of an intensely real encounter (**fig. 67**). Yet, bathed in an even light and mostly devoid of people, his pictures suggest an imaginary, timeless place, a constant heaven on earth unspoilt by the vagaries of the weather or human interference.

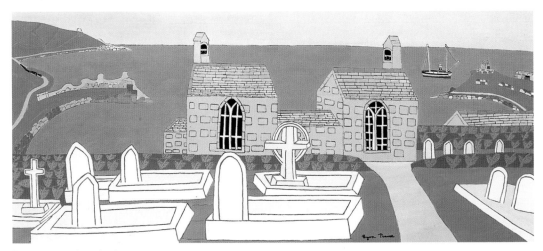

Fig. 67 *St Ives from the Cemetery* 1970
Oil on board, 53.3 × 121.9 Tate

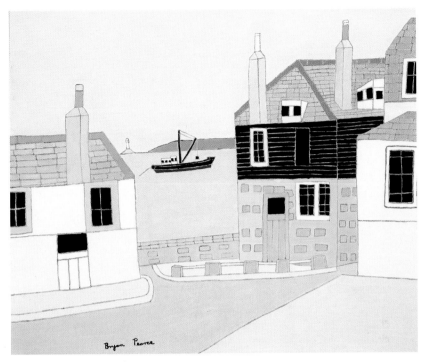

Fig. 68 *Westcott's Quay* 1980
Oil on board, 50.8 × 61 Private collection

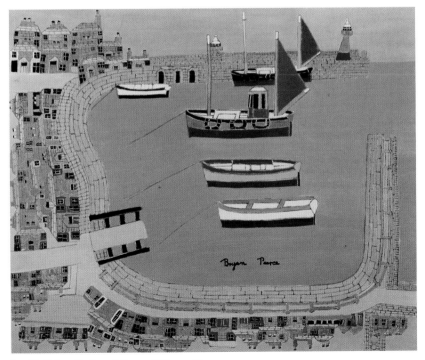

Fig. 69 *St Ives Harbour (all round) No.4* 1966
Oil on board, 50.8 × 61 Tate

Postscript: The Legacy of 'St Ives'

During the 1980s, the 'St Ives School' was treated as a historic movement by two major exhibitions, firstly at the Tate Gallery in 1985, and then in 1989 by a touring exhibition in Japan.[1] These exhibitions fixed the demise of the 'School' either to Lanyon's death in 1964, or to the deaths of Hepworth, Hilton and Wynter in 1975. The 'St Ives School' is usefully defined in art historical terms as having an end point, as it was undoubtedly a phenomenon shaped by the circumstances of the Second World War and its aftermath. But, of course, the story of the individual artists associated with the 'St Ives School' didn't end in the mid-1970s. Some of the key protagonists, for example, Frost, Barns-Graham, Heron and Mitchell, remained in west Cornwall, successfully pursuing their careers well after the international significance of the 'St Ives School' had waned (fig. 70).

West Penwith's reputation as a place governed by a certain 'quality of light', as Heron frequently observed, predominantly rural and remote, has continued to attract numerous artists for whom nature remains a vital touchstone. Such artists might be seen, indirectly, as heirs to the 'St Ives School' in terms of a romantic engagement with nature. For example, painter Richard Cook, who has lived and worked in Newlyn since 1985, has produced a body of work inspired by daily encounters with his natural surroundings, particularly the seascapes around Newlyn, Penzance and Lelant and the heathlands of Dartmoor. Internalising and distilling these experiences, he paints a memory of nature that – infused with the spirit of Turner and reminiscent of Gainsborough's fluid brushwork – is often dangerous, dramatic, full of passion and portent (fig. 71).

A growing desire to reassess, celebrate and rejuvenate St Ives as an art colony – partly stimulated by the retrospective exhibitions of the 1980s – culminated in the opening of Tate Gallery St Ives (now Tate St Ives) in 1993. Designed by architects David Shalev and Eldred Evans, the purpose-built gallery occupies the site of a former gasworks above Porthmeor Beach, looking out over the Atlantic Ocean. As a member of a national institution Tate St Ives is a regional art gallery with a national and international remit.

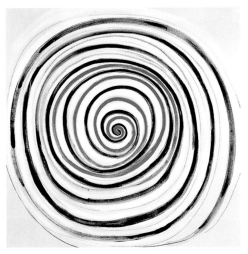

Fig. 70 Terry Frost, *R. B. and W. Spiral for A.* 1991
Oil and acrylic on canvas, 190.5 × 190.5 Tate

Fig. 71 Richard Cook, *Lelant, November* 1998
Oil on canvas, 152.7 × 197.9 Tate

Fig. 72 Partou Zia, *The Burning Bush* 2006
Oil on canvas, 152 × 183 Private Collection

Functioning as a showcase for the enjoyment, critical re-evaluation and interpretation of the 'St Ives School', the gallery also contributes to Cornwall's contemporary art scene through its programme of contemporary art exhibitions and events, which are both international and regional.

In 2003, the gallery introduced an artist-in-residence scheme providing regional artists with an opportunity to respond to Tate's collection and significantly develop their work. Since its earliest days as an art colony, St Ives has attracted international artists and provided a haven for émigrés. It has also attracted those interested in pursuing self-knowledge through process, and through testing the limits of physical and spiritual realities. Living and working in Newlyn since 1993, Iranian-born artist Partou Zia (1958–2008) was the first to benefit from the scheme. As a figurative painter-poet, she explored the spiritual or metaphysical potential of painting, drawing on personal imagery and her surroundings. Her visionary landscape *The Burning Bush* of 2006 features the biblical burning bush through which God miraculously spoke to Moses. Here, it becomes a symbol of regeneration, a reference to the unseen world of the spirit, which the artist, also pictured, invites us to recognise within ourselves (**fig. 72**).

Cornwall now boasts more artists than anywhere in the United Kingdom outside London, which is perceived as a legacy of the 'St Ives School' and its reputation. But how might 'St Ives' artists be defined today? In 2007, Tate St Ives provided a snapshot designed to open up debate around this question with a large-scale exhibition of contemporary art from the region, *Art Now Cornwall*. Given the number of artists working in the county, it could never be a comprehensive survey, but the show represented the work of twenty-eight artists and aimed to celebrate the diversity of local activity. The selection included artists working with themes and practices ranging from nostalgia and childhood to play and narration, appropriation and formalism.[2] Although including a variety of media – drawing, sculpture, installation, video and performative art practices – painting, both figurative and non-figurative, dominated the exhibition. There was also evidence of a continuing preoccupation with landscape and the natural environment, though often expressed through contemporary concerns such as global warming and pollution. For example, Ged Quinn's paintings address our complicated and conflicting relationship with landscape. Appropriating imagery from art history and literature he presents a distinctly dystopic view of nature. Portrayed as the construction of human values and the site of power relations, Quinn's images cast doubt over the belief that any encounter with nature can be innocent (**fig. 73**).

Art Now Cornwall represented artists across generations, yet the selection signalled that younger artists are again choosing to live and work in the region, which is being energised by further enhancement of its cultural infrastructure. Recent developments have included, for example, the refurbishment of the Newlyn Art Gallery and the opening of its new temporary exhibition space The Exchange in Penzance in 2007, the redevelopment of Porthmeor Studios, new studios at Trewarveneth in Newlyn and at Krowji, the Old Grammar School in Redruth, as well as the activities of contemporary arts organisations such as ProjectBase, commercial galleries and artist-led initiatives. Tate St Ives has also evolved its original role as 'showcase' for the 'St Ives

Fig. 73 Ged Quinn, *Cross in the Wilderness*, 2003–4 Oil on linen, 267.3 × 183 Tate

School' by working with a range of artists and partner organisations across the region to become a hub of exchange.

Future Colonies

Accounts of 'St Ives' accompanying the major retrospective exhibitions of the 1980s tended to endorse the received view, articulated by writers such as Denys Val Baker in the 1950s, that art made in Cornwall is inevitably shaped by its landscape. The specifics of the natural environment undoubtedly underpinned much 'St Ives' art. But, it is important to remember that many of its artists looked beyond the particular, exploring ideas of nature as a source for the development of a universal form of expression. Although connected to a particular place, 'St Ives' artists were investigating ways of looking at the world that had a contemporary, international relevance. Furthermore, despite the attraction of Penwith's peripheral location, 'St Ives' artists were intrinsically networked to art-world support structures and the international art community. One could argue, for example, that the idea of a 'St Ives School' emerged in London, through gallery exhibitions and critical reviews.

Contemporary communications networks make it easier than ever before to feel connected to other places. However, Cornwall remains geographically remote. Arguably, it is this physical sense of detachment and slower pace that continues to draw those seeking escape from the seemingly inexorable, technology-driven, hyper-mobility of contemporary life. Nostalgic escape to a rural location contributed to the declining relevance of 'St Ives' by the late 1960s. Yet, this kind of romantic search for an authentic, alternative reality has always been a key feature of modernity – think of Van Gogh's flight to Arles, or Gauguin's search for the 'primitive' in Brittany and Tahiti.

Today, the age-old tension between urban and rural, between centre and periphery, might be seen in the relationship of the local to the global, which is an issue of concern for the international contemporary art world. In today's complex, multi-centred, post-modern world, this community recognises that there is no single source or centre of modernity. Instead, the culturally significant and meaningful is now sought in exchanges between 'local modernities'. Sixty years ago the Penwith Society demonstrated that artists could be both integrated within a local community and relevant in a national and international context. The relationship of local cultural production to a global international culture remains a real concern for those engaged in contemporary art practice in the region today.

Many contemporary artists choosing to make work in relation to a particular place are attempting to resist the depersonalising tendencies of globalisation, which threatens to impose a bland, and often branded, uniformity. Since globalisation is now, most likely, an incontrovertible fact of life, they are using art as means of reasserting a sense of the singularity of lived experience. But, they are doing this within a wider, global context in the hope that a shared sense of human experience can be maintained. In conclusion, it seems that as a local centre of art production 'St Ives' – and indeed Cornwall as a whole – has much to offer contemporary debates.

Tate St Ives looks out over the Atlantic. Its distinctive, circular, glass-fronted gallery, which opens out its interior spaces to an expanse of sea and sky was designed to demonstrate the centrality of the natural environment to much of 'St Ives' art (fig. 74). Today, this openness might also serve as a reminder of Cornwall's history, not as an end place, but of its connectedness, across the ocean to the outside world.

Fig. 74 Tate St Ives interior with *Image II* by Barbara Hepworth

Chronology

1853
Penzance School of Art established (closed in 1984).

1877
Following the extension of the rail network to Penzance in 1876, Great Western Railway opens rail line to St Ives and the Tregenna Castle Hotel in 1878.

1883–4
Whistler, Sickert and Mortimer Mempes spend part of the winter painting in St Ives. Stanhope Forbes settles in Newlyn in 1884. By 1885 artists begin visiting and settling in St Ives. Sail lofts and cottages are converted into studios, while others are purpose built.

1887
James Lanham opens Lanham's Galleries in the High Street, St Ives, available for hire.

1888
St Ives Arts Club begins as a series of informal meetings (initially of male artists only) at Louis Grier's studio until permanent premises are secured in 1890.

1890
Artists' studios are open to the public one day in March. By the following year this is referred to as 'Show Day', becoming an established, popular event until the early 1950s.

1895
Passmore Edwards Gallery (now Newlyn Art Gallery) opens in Newlyn.

1914
Frances Hodgkins moves to St Ives (until 1920), working in no. 7, Porthmeor Studios.

1917
Cedric Morris spends a year in Zennor. In early 1919 he moves with Lett Haines to Newlyn, staying almost two years. They visit Cornwall often during the 1920s and become aware of Alfred Wallis in St Ives.

1919
Borlase Smart settles in St Ives. Marlow Moss lives in Cornwall, c.1919–26.

1920
From June to September Matthew Smith lives and paints at St Columb Major. Bernard Leach establishes the Leach Pottery in St Ives. With Shoji Hamada, he builds the first Japanese climbing kiln in Europe.

1926
Christopher Wood visits St Ives.

Fig. 75 Christopher Wood on a Cornish Beach c.1926 Tate

1927
The St Ives Society of Artists is formed under the Presidency of Moffat Lindner (until 1946).

1928
The St Ives Society of Artists acquires one of the Porthmeor Studios in St Ives as a gallery and headquarters. In June, Julius Olsson opens the Porthmeor Gallery (in Porthmeor Studios) as an exhibition space for the St Ives Society of Artists. In August Ben and Winifred Nicholson stay with Irene and Marcus Brumwell at Pill Creek, Feock, near Truro. Wood and John Wells are also guests. Nicholson and Wood visit St Ives and come across Alfred Wallis, who started painting around 1925. Nicholson subsequently spends three weeks, and Wood three months in St Ives.

1930

Denis Mitchell moves from Swansea to St Ives.

1936

John Wells becomes a doctor in the Scilly Isles until 1945. William Scott visits Cornwall and stays for six months at Mousehole.

1937

Peter Lanyon meets Adrian Stokes and makes his first abstract work. Stanley Spencer spends six weeks in St Ives, where he paints six views.

1938

Leonard Fuller and his wife Marjorie Mostyn settle in St Ives. He opens the St Ives School of Painting in April.

1939

Adrian Heath attends the Stanhope Forbes Painting School, Newlyn. Lanyon studies at the St Ives School of Painting. In April, Adrian Stokes and Margaret Mellis move to Little Park Owles, Carbis Bay. Their visitors include Victor Pasmore, Thelma Hulbert and William Coldstream. On 25 August Nicholson and Hepworth arrive and move to 'Dunluce' after Christmas. Naum and Miriam Gabo arrive by mid-September and move to 'Faerystones' near Little Park Owles. Oskar Kokoschka spends nine months painting at Polperro (1939–40).

1940

Lanyon joins the Air Force (until the end of 1945) and gives Gabo use of his studio. Wilhelmina Barns-Graham comes to stay with Mellis. Smart finds her a studio (no. 3, Porthmeor Studios).

1940–5

Among the visitors to St Ives are Alistair Morton, Margaret Gardiner, Desmond Bernal, Elizabeth and John Summerson, E.H. Ramsden, Margot Eates, Herbert Read, Stephen Spender, Jim Ede, John Skeaping, Cyril Connolly, Helen Sutherland and Peter Gregory.

1944

Patrick Heron works at the Leach Pottery (1944–5). He makes friends with Nicholson, Hepworth, Gabo, Stokes and their circle. Scottish poet W.S. Graham and his wife Nessie Dunsmuir move to Praa Sands. Their visitors include Robert Colquhoun, Robert McBryde, John Minton and Bryan Wynter. The Grahams move to Mevagissey in 1946, and from 1956 live at Gurnard's Head.

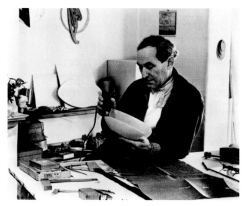

Fig. 76 Studio St Ives, Naum Gabo in his studio c.1944
Tate Gallery Archive

Fig. 77 St Ives School of Painting c.1944 Tate Gallery Archive

1945

St Ives Society of Artists moves to the deconsecrated Mariner's Church near the harbour. From 1945 Endell Mitchell, landlord of the Castle Inn, exhibits work by local 'advanced' artists in the saloon bar. Bryan Wynter moves to St Ives, settling at the Carn, Zennor. Guido Morris arrives from London in November and sets up Latin Press.

1946

Terry Frost moves to Cornwall, first to Carbis Bay, then to 12 Quay Street, St Ives. Heron stays in Mousehole over the summer. From around 1946 William Scott spends summers in Cornwall, meeting Lanyon, Frost, Wynter and Nicholson. The Crypt Group holds its first exhibition in September and Stokes leaves Cornwall, followed by Mellis in December and Gabo, who leaves for America.

1947

In May, Borlase Smart is elected president of the St Ives Society of Artists, but dies suddenly in November. In the summer David Bomberg paints around Zennor. In August, the Crypt Group holds its second exhibition. David Haughton and David Lewis move to Cornwall from London. Married to Barns-Graham from 1949 to 1963, Lewis was curator of the Penwith Gallery from 1951–4. He leaves St Ives in 1956.

1948

Borlase Smart Memorial Fund is set up to purchase Porthmeor Studios, offered for sale by Moffat Lindner. The studios are secured with an additional interest free loan from the Arts Council and managed by Trustees of the Borlase Memorial Trust. John Armstrong moves to Mousehole until 1955. William Gear paints in St Ives in June. The Crypt Group holds its final exhibition in August.

1949

On 5 February the 'advanced' artists resign from the St Ives Society of Artists and The Penwith Society of Arts in Cornwall is founded on 8 February at the Castle Inn, as a tribute to Borlase Smart. The nineteen founder members are: Shearer Armstrong, Wilhelmina Barns-Graham, Sven Berlin, David Cox, Agnes Drey, Leonard Fuller, Isobel Heath, Barbara Hepworth, Marion Grace Hocken, Peter Lanyon, Bernard Leach, Denis Mitchell, Guido Morris, Marjorie Mostyn, Dicon Nance, Robin Nance, Ben Nicholson, Hyman Segal and John Wells. Herbert Read is invited to be the first President and Leonard Fuller Chairman. Unlike the St Ives Society of Artists, the Penwith includes both artists and craftsmen as members and additional lay members. In November the divisive 'A-B-C' rule is introduced categorising members as 'representational', 'abstract' and 'craftsmen' respectively. By February 1950 many members resign in protest, including Lanyon, Morris and Berlin. Nicholson successfully applies for tenancy of no. 5, Porthmeor Studios, formerly occupied by Borlase Smart. In August Hepworth buys Trewyn Studio in St Ives. Canadian writer Norman Levine moves to St Ives.

1950

Hepworth represents Britain at the Venice Biennale. Frost takes over no. 4, Porthmeor Studios. Pasmore visits St Ives to meet Nicholson. Paul and June Feiler begin visiting West Cornwall. Frost and Wells begin working as assistants for Hepworth (joined by John Milne, 1952–4).

1951

Penwith Society artists winning Festival of Britain art prizes include Lanyon for painting, Hepworth for sculpture and Leach for crafts. Wynter teaches at Bath Academy of Art, Corsham until 1956 (as does Lanyon between 1950 and 1957, and Frost between 1952 and 1954). Following their divorce, Nicholson moves to Trezion on Salubrious Place, and Hepworth to Trewyn Studio. Patrick Hayman lives in Penwith until 1953. Adrian Heath visits St Ives in the summer. Alan Lowdnes moves to St Ives around 1951.

1953

Morris and Berlin leave St Ives. Bryan Pearce starts to draw and paint.

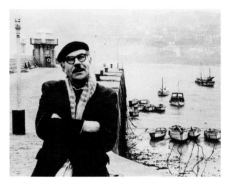

Fig. 78 Terry Frost on Smeaton's Pier, St Ives c.1953
Tate Gallery Archive

1954

Nicholson's work is shown at the Venice Biennale and later in Paris; he receives the Ulissi Award. Brian Wall moves to St Ives.

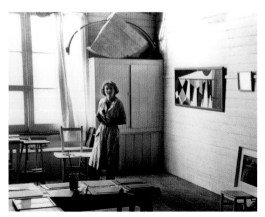

Fig. 79 Photograph of Wilhelmina Barns-Graham in no. 1 Porthmeor Studios 1954 Tate Gallery Archive

1955

Patrick and Delia Heron buy Eagle's Nest, moving there early in 1956. Karl Weschke and Trevor Bell move to Tregerthen, Zennor, and Anthony Benjamin arrives in Cornwall. Nicholson has a retrospective at the Tate Gallery. Lanyon and William Redgrave found the St Peter's Loft School of painting as a summer school until 1960.

1956

The Arts Council exhibition *Modern Art in the United States*, selected from the collections of the Museum of Modern Art, New York is held at the Tate Gallery in London (January–February). Roger Hilton visits Heron at Eagle's Nest. Lanyon buys Little Park Owles.

1957

Nicholson resigns from the Penwith Society. The 'A' and 'B' group rule is dropped. Hilton rents space in Newlyn, painting there each summer for the next few years. Sandra Blow visits the Herons. She rents a cottage at Tregerthen for a year and becomes an associate member of the Penwith. Bob Law moves to St Ives, later moving to Nancledra, until 1960. Joe and Jos Tilson buy a cottage in Nancledra and spend summers there (1958–62). Peter Blake visits them. Alan Davie visits the Herons around 1957 and later has a cottage near Land's End converted into a studio and living space.

1958

In June, Nicholson moves to Ticino, Switzerland with his third wife Felicitas Vogler. He recommends that Heron takes over no. 5, Porthmeor Studios.

1959

The Arts Council exhibition *The New American Painting* is held at the Tate Gallery (February–March). In July, Clement Greenberg visits Heron, staying for six days. Mark Rothko visits St Ives with his family in August and stays with Lanyon for about a week. Rothko meets Davie, Heron, Feiler, Frost and Wynter. From September 1959 to January 1960 Francis Bacon stays in St Ives, painting in no. 3, Porthmeor Studios.

1960

Penwith Society moves to St Peter's Loft premises, acquired with support of a Gulbenkian grant and loan from St Ives Borough Council. Tony O'Malley settles in St Ives. *Situation: An Exhibition of Abstract Painting* at R.B.A. Galleries excludes St Ives artists because of their references to 'landscape, boats and figures'. Bell leaves St Ives (returning to live in Penwith in 1996).

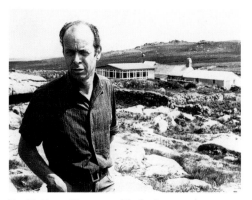

Fig. 80 Bryan Wynter outside the Carn c.1962 Tate Gallery Archive

1963
Frost leaves St Ives for Banbury (returns to live
in Newlyn, 1974). Patrick Hayman lives in St Ives
1963–4.

1964
Hilton shows paintings in the British Pavilion at
the Venice Biennale. 31 August, Lanyon dies after
a gliding accident.

1965
Hepworth is appointed D.B.E. Hilton moves from
London to Botallack Moor, St Just.

1968
Leach and Hepworth receive honorary Freedom
of Borough of St Ives. Leach is appointed C.H.
in 1973.

1975
Deaths of Wynter (11 February), Hilton
(23 February) and Hepworth (20 May).

Notes

'St Ives' Artists: An Introduction

1. For details of this incident see Marion Whybrow, *St Ives 1883–1993: Portrait of an Art Colony*, Woodbridge 1994, p. 119.
2. John Wells, Letter to Sven Berlin, 1945, TGA 8718.
3. See Chris Stephens, *Bryan Wynter*, London 1999, pp. 6, 15–16.
4. Ben Nicholson, quoted in *Ben Nicholson*, exh. cat., Galerie Beyeler Basel, 1968, unpag.
5. Nicholson took over studio number five, formerly occupied by Borlase Smart, who had been a student of Julius Olsson. When Smart died in 1947, his memorial fund and Arts Council support secured the purchase of all twelve studios in 1949 from Moffat Lindner. On his departure from Cornwall in 1958, Nicholson requested that his studio be made available to Patrick Heron, who subsequently worked there for forty-one years. The studios are currently managed by The Borlase Smart, John Wells Trust for the sole use of artists.
6. Victor Pasmore, quoted in *Tate St Ives: An Illustrated Companion*, London 1993, p. 42.
7. Though bringing different types of abstraction together Alloway's *Nine Abstract Artists* only thinly disguised his disregard for St Ives style abstraction, writing that in St Ives 'the landscape is so nice nobody can quite bring themselves to leave out of their art'.
8. See Chris Stephens, 'St Ives Artists and Landscape', unpublished PhD, University of Sussex, 1997, p. 90.
9. Ibid., pp. 45–8.
10. William Scott, quoted in London 1993, p. 59.
11. Lawrence Alloway, 'English and International Art', *European Art This Month*, vol. 1, nos. 9–10, July/Aug. 1957, p. 25.

Postscript: The Legacy of 'St Ives'

1. *St Ives 1939–64: Twenty-five Years of Painting, Sculpture and Pottery*, exh. cat., Tate Gallery, London 1985; *St Ives*, exh. cat., Hyogo Prefectural Museum of Modern Art, Japan, 1989.
2. Susan Daniel Mc-Elroy and Sara Hughes, *Art Now Cornwall*, exh. cat., Tate St Ives, 2007, p. 4.

General

Art Now Cornwall, exh. cat., Tate St Ives 2007

Denys Val Baker, *Britain's Art Colony by the Sea* 1959, rev. Bristol 2000

Michael Bird, *The St Ives Artists: A Biography of Place and Time*, Aldershot 2008

Tom Cross, *Painting in the Warmth of the Sun: St Ives Artists, 1939–75*, Penzance 1984, rev. Tiverton 1995

Tom Cross, *The Shining Sands: Artists in Newlyn and St Ives, 1880–1930*, Tiverton 1994

Peter Davies, *The St Ives Years (Essays on the Growth of an Artistic Phenomenon)*, Wimbourne 1984

Peter Davies, *St Ives: Innovators and Followers*, Abertillery 1994

Margaret Garlake, *New Art New World: British Art in Postwar Society*, New Haven and London 1998

St Ives, exh. cat., Hyogo Prefectural Museum of Modern Art, Japan 1989

St Ives 1939–64: Twenty-five Years of Painting, Sculpture and Pottery, exh. cat., Tate Gallery 1985

Tate St Ives: An Illustrated Companion, London 1993

Marion Whybrow, *St Ives 1883–1993: Portrait of an Art Colony*, Woodbridge 1994

Artists

Trevor Bell: Beyond Materiality – Paintings and Drawings 1967–2004, exh. cat., Tate St Ives 2004

Alan Bowness, *Bryan Wynter 1915–1975: Paintings, kinetics and works on paper*, exh. cat., Hayward Gallery, London 1976

Virginia Button, *Christopher Wood*, London 2003

Virginia Button, *Ben Nicholson*, London 2007

Andrew Causey, *Peter Lanyon: Modernism and the Land*, London 2006

Richard Cook: New Paintings, exh. cat., Austin/Desmond Fine Art, London 2003

Emanuel Cooper, *Bernard Leach: Life and Work*, New Haven and London 2003

Penelope Curtis, *Barbara Hepworth*, London 1998

Denis Mitchell: Ascending Forms, exh. cat., Tate St Ives 2005

Edmund de Waal, *Bernard Leach*, London 1997

Paul Feiler: The Near and the Far – Paintings 1953–2004, exh. cat., Tate St Ives 2005

Matthew Gale, *Alfred Wallis*, London 1998

Matthew Gale and Chris Stephens, *Barbara Hepworth: Works in the Tate Gallery Collection and the Barbara Hepworth Museum, St Ives*, Tate Publishing 1999

Margaret Garlake, *Peter Lanyon*, London 1998

Ged Quinn: Utopia Dystopia, Tate St Ives 2004

Mel Gooding (ed.), *Painter as Critic: Patrick Heron, Selected Writings*, London 1998, repr. 2001

Lynne Green, *W. Barns-Graham: A Studio Life*, Aldershot 2001

A.M. Hammacher, *Barbara Hepworth*, London 1968

Martin Hammer and Christina Lodder, *Constructing Modernity: the art and career of Naum Gabo*, New Haven and London 2000

Andrew Lambirth, *Roger Hilton: The Figured Language of Thought*, London 2007

Jeremy Lewison, *Karl Weschke: Portrait of a Painter*, Penzance 1998

Jeremy Lewison (ed.), *Ben Nicholson*, exh. cat., Tate Gallery, London 1993

Norbert Lynton, *Ben Nicholson*, London 1993

Michael McNay, *Patrick Heron*, London 2002

Matthew Rowe, *John Wells: The Fragile Cell*, Tate Publishing 1998

Chris Stephens, *Bryan Wynter*, London 1999

Chris Stephens, *Terry Frost*, London 2000

Chris Stephens, *Roger Hilton*, London 2006

St Ives All Around: The Paintings of Bryan Pearce, exh. cat., Tate St Ives 2007

Karl Weschke: Beneath a Black Sky – Paintings and Drawings 1953–2004, exh. cat., Tate St Ives 2004

Wilhelmina Barns-Graham: Movement and Light Imag(in)ing Time, exh. cat., Tate St Ives 2005

Partou Zia: Entering the Visionary Zone, exh. cat., Tate St Ives 2003